© 2001 Mandragora. All rights reserved.

Mandragora s.r.l.
piazza Duomo 9, 50122 Firenze
www.mandragora.it

The essay by Franco Cardini was first published in 1991 by Arnaud, Florence.
The version which appears here has been updated and expanded by the author.

Edited, designed and typeset by
Monica Fintoni, Andrea Paoletti, Franco Casini

English translation by Mark Roberts

Photographs: Antonio Quattrone, Nicolò Orsi Battaglini, Mandragora Archive

Printed in Italy

ISBN 88–85957–64–1

This book is printed on TCF (totally chlorine free) paper.

Franco Cardini

The Chapel of the Magi in Palazzo Medici

Preface by Cristina Acidini Luchinat

With an essay by Lucia Ricciardi

Mandragora

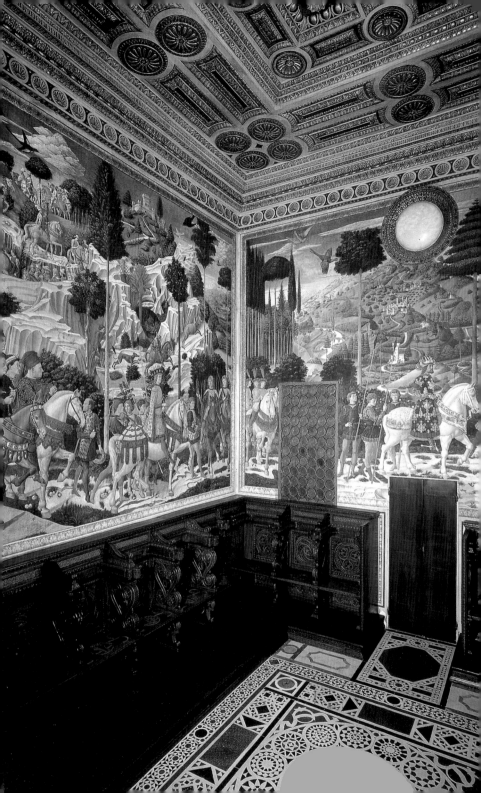

PREFACE

The Chapel of the Magi in Palazzo Medici-Riccardi is one of those places in Italy—there are a certain number of them, though not an enormous number—in which history and art combine to bear witness to the past in a way that is absolutely exceptional. In this case we are dealing with a period in the past that has been extraordinarily celebrated, studied and loved, so as to achieve an almost mythic status: the age of the Renaissance in Medicean Florence.

The very location of the chapel, secret and precious like a treasure-chamber fitted into the massive structures of Michelozzo's palazzo, denotes its function as the religious heart of the family life that went on within those walls: a space for private devotion, in the first instance, but when necessary the scene of magnificent displays of hospitality for the benefit of distinguished guests, who would be overwhelmed by the splendour of the sumptuous decorations and furnishings.

The route to the chapel—dictated by modern museum-visiting considerations—still reserves a surprise for anyone experiencing it for the first time. From Michelozzo's harmonious courtyard we climb to the first floor by a grandiose staircase, built in the late 17th and early 18th century but nevertheless respecting the tradition of 15th-century Florentine architecture, with its pleasing contrast between the grey *pietra serena* and the white walls. We enter the chapel diagonally, through a little doorway at one corner, and we find ourselves at once enveloped in a colourful embrace, in a space where at first glance it is difficult to find our bearings. We are aware of distinct architectural masses, the powerful modelling of the richly carved and gilded ceiling, the ordered polychrome saraband of angels and men and beasts standing out against a luminous landscape background on the walls, the sober presence of the inlaid choir-stalls, the magnificence of the floor with its marble and porphyry inlay. If we study the faces of visitors, even the most world-weary, we find that wonder and disorientation are the most frequent reactions. Statesmen from all over the world, differing in culture and religious background, unused as they are to betraying emotion in any cir-

cumstances, have rendered homage by their admiration to the exceptional qualities of this chapel. And such is the wonder, such the disorientation, that hardly anyone is aware of having entered slantwise into a space that was planned to have a central entrance, and of having to adapt to asymmetry in a room originally planned with the most rigorous symmetry.

History has not been kind to the Chapel; indeed it threatened the Chapel's very existence at end of the 17th century, when the Marchesi Riccardi, who had succeeded the Medici as owners of the palazzo, took it into their heads to build an enormous staircase cutting right through the area that had been designated for the Chapel by Michelozzo in 1458. The protests of cultivated Florentines fortunately put a brake on these plans, and the Chapel was saved: however, a portion of it was indeed reshaped in order to make room for a landing on the new staircase.

Let us imagine that we have turned back the inexorable clock of history, and that we are able to enter—just as the Medici did—by means of the narrow corridor leading from the apartments, crossing the threshold of the central door (which still exists: it communicates with the present-day offices of the Prefect), passing beneath the frescoed image of the *Mystic Lamb* set amid apocalyptic symbols. We enter a room dedicated to the *Journey of the Magi*, its left half still equal to its right: our gaze runs to the altar, at the back of the recessed *scarsella*, the small rectangular apse where still stands the altarpiece of the *Adoration of the Child Jesus* by Filippo Lippi, surmounted by images of the four Evangelists frescoed, like the other paintings covering the walls, by Benozzo Gozzoli. In the almost total absence of natural light, flickering candles illuminate the precious Reliquary of the Passion (or 'Libretto' Reliquary), gleaming with gold and jewels, standing on the altar. The walls shine with the gilded haloes and garments, with the silver of the lance-tips; against an emerald-green landscape that stretches away into darkness, the mounted Magi and their entourage look like marble equestrian statues.

History, as I said, has not been kind to the Chapel. The beautiful reliquary is no longer there (though it can be seen not far away, in the Opera del Duomo Museum), nor is Filippo's altarpiece (it is now in the Neue Gemäldegalerie in Berlin, and has been replaced in the Chapel by an old copy); two of the four painted symbols of the Evangelists

were destroyed when a window was made (it was later bricked up). But the splendour of the Chapel, due as much to its symbolic and historical resonance as to its artistic and material richness, has managed to endure, and indeed has been renewed by successive restorations; in the distant past and until the early 20th century damaged portions were meticulously repainted and restored, while in 1988–1992 structural damage was repaired and grime and discoloured varnish were removed from the glorious surfaces of wood, marble and frescoes.

Working with the team of restorers, technicians and experts who carried out this latest restoration (finished in time for the quincentenary of Lorenzo the Magnificent in 1992), I was able to examine the Chapel at close quarters, to dismantle mentally (and to some extent even physically) this magical Medicean treasure-chamber, and thus to appreciate, despite the damage suffered, the supreme skill of the craftsmen who made its various parts. First in importance was Michelozzo himself, who wisely decided to distance the Chapel from the massive external walls of the palazzo, which were prone to dangerous static shifts, so that it became a 'box' enclosed by, but not part of, the surrounding architecture. Technical analyses, carried out and interpreted by the Opificio delle Pietre Dure together with the Florentine Superintendency, revealed the experimental and adventurous distribution of colours that Benozzo Gozzoli had employed in painting the two principal subjects, the *Journey of the Magi* on the chapel walls and the *Angelic Hosts* in the *scarsella*: gold, silver, red lacquer and ultramarine, all valuable pigments, applied *a secco* with vegetable glues on the wall, interspersed with passages of true fresco using earths. Thanks to the protective darkness of the space, greens of the most varied hues—pine, emerald, silver-green, green ochre—have maintained their original colours with extraordinary fidelity, so as to preserve intact the harmonious and variegated image of a landscape tended by human hands, such as Benozzo had come to love and to understand on his travels through Tuscany, Umbria and Latium. The detailed, chiselled treatment bears witness to the multiple talents of Benozzo, who had assisted the great goldsmith and sculptor Lorenzo Ghiberti in finishing off the gilded bronze reliefs of the 'Doors of Paradise' for the Baptistery in Florence, and had also worked as a miniaturist.

The restorers of the Consorzio Pegasus carried out a correct and sensitive intervention, safeguarding the balanced system of chromatic and material relations among the various components of the Chapel, and within the pictorial cycle in its entirety.

Nearly ten years have gone by since the conclusion of the restoration and the publication of scholarly studies (both as part of the Laurentian celebrations and independently), and it is now highly opportune that the essence of these writings should have been distilled by Franco Cardini, the author of so many enlightening pages on the Florentine Middle Ages and Renaissance, as well as on the Chapel itself. His synthesis is completed by Lucia Riccardi's essay, full of useful information on the heraldic, symbolic and allegorical imagery related to the Medici family.

As I look back over the last decade, surveying the burgeoning bibliography on the palazzo and its chapel, I recall with pleasure the conference on Michelozzo held in Florence in 1996, and also the continuing attention paid to Benozzo Gozzoli both in Italy and abroad. Articles and monographs have appeared, and a national Committee has been formed, with a view to organising a monographic exhibition; this is undoubtedly a beneficial effect of the critical revaluation of the Chapel and its artist subsequent to the restoration. Moreover, there have been immediate and effective interventions of protection and restoration of Benozzo's frescoes—the *Franciscan Stories* in the apse of the church of San Francesco in Montefalco had been seriously threatened by the earthquake that struck Umbria in September 1997.

The improvements made to the visitors' route through Palazzo Medici-Riccardi at the beginning of the 21st century once again place the Chapel at the centre of an informed appreciation, supported by historical studies. For if it is true—as we believe—that every ancient testimony of human creativity bears the marks of its own uniqueness and irreplaceability, then it is all the more certain that the Chapel of the Magi is unique and irreplaceable, where art, faith, culture and power came together in an exceptional combination of circumstances, to give to the world a masterpiece of evocative capacity that is without equal. On the walls of the Chapel, among the precious furnishings that surround them, Benozzo's paintings link the remote past of the Nativity and the Journey of the Magi with the con-

temporary world of 15th-century Florence, presenting us with a collective portrait—both fascinating and mysterious—of a dynasty that was *primus inter pares* in the society of its time: the Medici, at the peak of their influence and riches in the happy year 1456, from the aged Cosimo to his first-born son Piero and his grandsons Lorenzo and Giuliano, with their relatives and associates and distinguished guests. We who are admitted to these memories, still so vivid and expressive after more than five centuries, enjoy a journey back through time, one that thrills and enriches us.

Cristina Acidini Luchinat

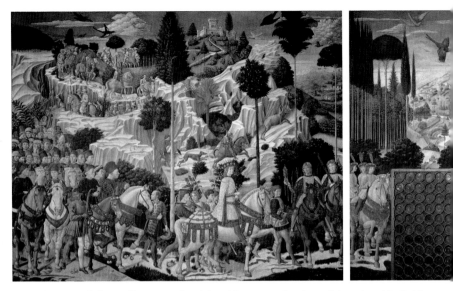

Above, the three walls frescoed by Benozzo: from left to right, east, south and west. Below, plan of the first floor of Palazzo Medici-Riccardi (with the Chapel indicated in yellow), and plan of the Chapel.

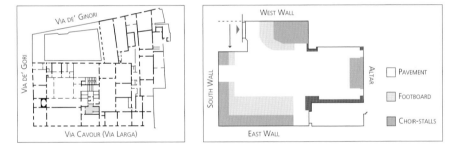

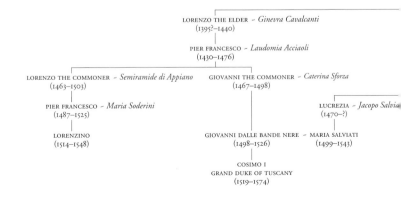

LORENZO THE ELDER ~ *Ginevra Cavalcanti* (1395?–1440)	
PIER FRANCESCO ~ *Laudomia Acciaioli* (1430–1476)	
LORENZO THE COMMONER ~ *Semiramide di Appiano* (1463–1503)	GIOVANNI THE COMMONER ~ *Caterina Sforza* (1467–1498)
PIER FRANCESCO ~ *Maria Soderini* (1487–1525)	LUCREZIA ~ *Jacopo Salviati* (1470–?)
LORENZINO (1514–1548)	GIOVANNI DALLE BANDE NERE ~ MARIA SALVIATI (1498–1526) (1499–1543)
	COSIMO I GRAND DUKE OF TUSCANY (1519–1574)

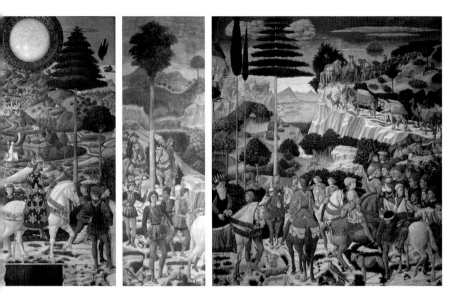

Below, and on the page opposite, the Medici family tree from Chiarissimo to Grand Duke Cosimo I.
The sign ~ indicates marriage, the broken line (---) illegitimate descent.

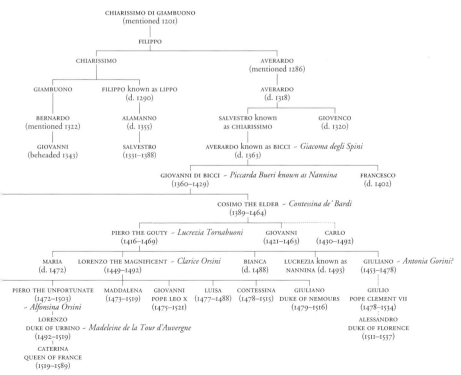

CHIARISSIMO DI GIAMBUONO
(mentioned 1201)

FILIPPO

CHIARISSIMO AVERARDO
 (mentioned 1286)

GIAMBUONO FILIPPO known as LIPPO AVERARDO
 (d. 1290) (d. 1318)

BERNARDO ALAMANNO SALVESTRO known GIOVENCO
(mentioned 1322) (d. 1355) as CHIARISSIMO (d. 1320)

GIOVANNI SALVESTRO AVERARDO known as BICCI ~ Giacoma degli Spini
(beheaded 1343) (1331–1388) (d. 1363)

 GIOVANNI DI BICCI ~ Piccarda Bueri known as Nannina FRANCESCO
 (1360–1429) (d. 1402)

 COSIMO THE ELDER ~ Contessina de' Bardi
 (1389–1464)

 PIERO THE GOUTY ~ Lucrezia Tornabuoni GIOVANNI CARLO
 (1416–1469) (1421–1463) (1430–1492)

MARIA LORENZO THE MAGNIFICENT ~ Clarice Orsini BIANCA LUCREZIA known as GIULIANO ~ Antonia Gorini?
(d. 1472) (1449–1492) (d. 1488) NANNINA (d. 1493) (1453–1478)

PIERO THE UNFORTUNATE MADDALENA GIOVANNI LUISA CONTESSINA GIULIANO GIULIO
 (1472–1503) (1473–1519) POPE LEO X (1477–1488) (1478–1515) DUKE OF NEMOURS POPE CLEMENT VII
~ Alfonsina Orsini (1475–1521) (1479–1516) (1478–1534)

LORENZO ALESSANDRO
DUKE OF URBINO ~ Madeleine de la Tour d'Auvergne DUKE OF FLORENCE
(1492–1519) (1511–1537)

CATERINA
QUEEN OF FRANCE
(1519–1589)

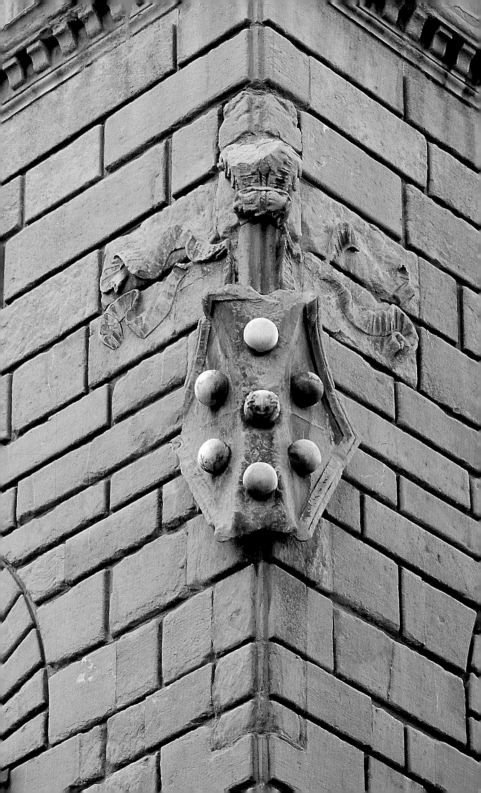

A Palace Chapel

Cosimo de' Medici, son of Giovanni, was not yet known as 'the Elder' (in fact, he was just over thirty) when in 1422 he was granted the papal privilege of a portable altar. Twenty-three years later, in 1445, the architect Michelozzo began work on the construction of the large palazzo "on the corner of Via Larga" for Cosimo. Work was to go on until 1457. These were the great years of business expansion for the Medici: it has been calculated that over the period 1435 to 1455 the great family of financiers and merchants amassed around 20,000 florins every year. An energetic ruler of both the political and economic fortunes of his family, Cosimo had already become the 'cryptolord'—as he has been called—of Florence when (in 1449, it would appear) he conceived the idea of finding room in his new palazzo for a chapel, though he was never to see it finished. Work continued for over twenty years, certainly until after 1469, and was followed enthusiastically first by his son Piero and later by his grandsons Lorenzo and Giuliano.[1]

The original, Brunelleschi-style layout of the chapel was extremely simple: the space was "divided internally into two juxtaposed squares: the main body of the chapel, and a raised apse with the altar".[2]

By 1459 the architectural outline had been finished, and it was here that Cosimo ceremoniously received Galeazzo Maria, the son and ambassador to Florence of the great ally of the moment, Francesco Sforza, Duke of Milan. The chapel had been conceived to be seen in semi-darkness, illuminated by flickering candle-flames and torches, but on that occasion it glowed with golden and polychrome decorations and with drapes of precious fabrics. The walls had not yet been frescoed with the fabulous narrative that Vasari would later refer to simply as "the Story of the Magi". It appears that the chapel had already been dedicated to the Holy Trinity, as celebrated by Filippo Lippi's altarpiece—an *Adoration of the Child Jesus* where, in accordance with the Vision of St Bridget of Sweden, the Trinity played a central role.[3] Added to the altar, and to the *Adoration* painted on the panel hanging over it, was the

Opposite, the Medici coat of arms on the façade of Palazzo Medici-Riccardi, on the corner of Via Cavour and Via de' Gori.

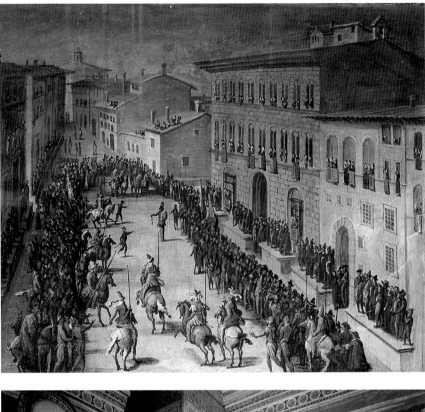

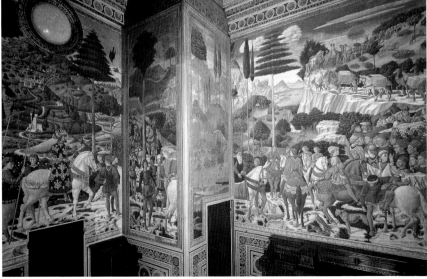

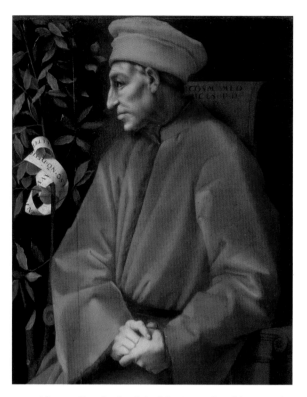

Opposite, above, Giovanni Stradano, *Joust of the Saracen in Via Larga* (Florence, Palazzo Vecchio, Apartment of Eleonora, Room of Gualdrada), showing the palazzo as it appeared before the 17th-century alterations. Below, the frescoes painted by Benozzo Gozzoli on the south and west walls of the Chapel of the Magi; in the figures of the aged Magus and his mule, split up and distributed on two levels, we can see clearly the effects of the protrusion of a substantial portion of the west wall, due to the intervention ordered by the Marchesi Riccardi.

Right, the famous portrait of Cosimo the Elder painted by Jacopo Pontormo around 1518 on the basis of 15th-century iconographic tradition (Florence, Uffizi Gallery). On the scroll, the motto *Uno avulso no(n) deficit alter* ('As one is torn away another appears') celebrates the continuity of the dynasty.

magnificent *Cavalcade of the Magi* completed by 1462 by Benozzo Gozzoli, who started work in the summer of 1459 before moving on to San Gimignano, where he was to narrate in festive hues the *Life of St Augustine*. The work in Florence was followed closely by Cosimo's son Piero, known as 'the Gouty', as well as by Roberto Martelli, protector of Donatello. It seems that Gozzoli began by painting the symbols of the Evangelists and the angels in the altar niche before applying himself to the chapel walls.[4]

The chapel was soon to undergo modifications of various kinds—as early as 1494, when the Medici were banished from Florence, and at the end of the 17th century, when the Riccardi, the new owners of the palazzo, had the grand staircase opened. In order to make room for the latter, there was even talk of demolishing the entire chapel, which in the end was somewhat reshaped, although "the portions of the walls in the south-west corner were skilfully moved, the painted plaster being safeguarded as far as possible".[5] The alterations and repainting which ensued

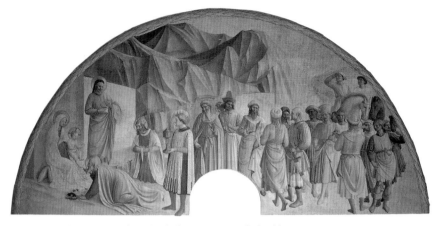

were enough to jeopardise the balance accomplished by the fortunate encounter between Michelozzo and Gozzoli, though not as definitely and irreversibly as to ruin it. Restoration by Antonio Marini followed in 1837, then works in 1875–1876, which altered the entrance to the chapel. Refurbishing in 1929 brought a few elements back to their presumed original aspect, especially in the area of the apse, where Michelozzo's altar was repositioned and the large 19th-century window in the neo-Renaissance style, which distorted lights and proportions, was closed. After careful restoration work carried out in 1988–1990, the chapel today looks quite as it did in the 15th century—except of course for the 17th-century reshaping and other 'minor' interventions which are difficult to eliminate at this point.

The *Cavalcade* also bears the signs of ageing and of the alterations suffered by the chapel. All the same, it can still be 'read' and enjoyed today in all its fable-like splendour. Benozzo loved the theme of the Magi at least as much as his illustrious patron did. It was no coincidence that he had worked at length in the convent of San Marco where Cosimo used to spend hours in meditation. Between 1446 and 1447 the artist—at least according to some scholars—had already painted an *Adoration of the Magi* to a design by Fra Angelico in the favourite cell of the *pater patriae*, depicting a scene filled with Eastern curiosities and reminiscences that some have associated, not altogether unlikely, with the stir created a few years earlier by the visiting Greeks during the Council of Florence (1439–1442).[6]

In the larger of the two cells which composed the private apartment of Cosimo the Elder in San Marco there is a lunette with the *Adoration of the Magi*. In the fresco – attributed to the circle of Fra Angelico, of whom Benozzo was a pupil – some have seen echoes of the Council of Florence (1439-1442).

Magi Stellarum Observatores

Magi stellarum observatores,
ad Christum vitae ducem stella duce venerunt,
pretiosum vitae thesaurum offerentes.

The *Magi stellarum observatores* appear in an antiphonary illuminated by Monte di Giovanni (AOSMF, Cod. C n. 11, fol. 1r, initial M: *Magi videntes stellam*). The decoration was probably commissioned on the occasion of the visit to Florence by Pope Leo X in 1516: Giovanni de' Medici, born in 1475 to Lorenzo the Magnificent and Clarice Orsini, had been elected to the papal throne in 1513.

When Marsilio Ficino in his *De vita* eulogised the Magi, "the first-fruits of the Gentiles", the first among the pagans to hasten to the stable in Bethlehem to adore the Divine Child, the cult of the mysterious Wise Men from the East had become well established in Florence and in the Medici home in particular. Benozzo Gozzoli had not borrowed the passion for the procession of gift-bearers to the stable from Fra Angelico alone. Most probably he knew of the various sculptural or pictorial versions of the Gospel episode that the foremost painters of the Quattrocento had produced: Lorenzo Ghiberti in the north door of the

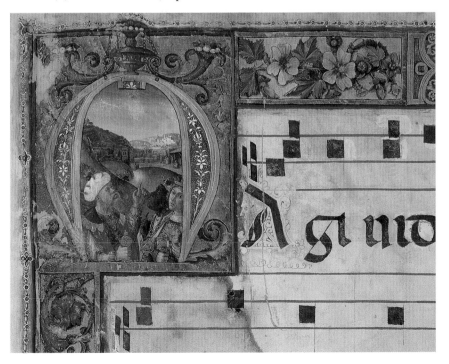

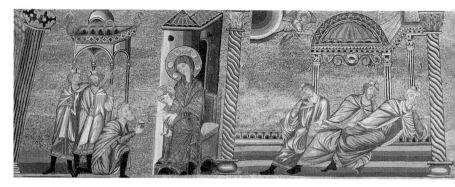

Baptistery, Lorenzo Monaco, Gentile da Fabriano (who had painted an acclaimed *Adoration* for Palla Strozzi), Domenico Veneziano in the tondo now in Berlin, Masaccio, and a myriad of minor artists. The tradition was to continue up until Botticelli, Ghirlandaio, Leonardo da Vinci and beyond. Besides, the theme of the Magi did not arise in Quattrocento art out of thin air. There had been notable early-Christian and medieval precedents and, more recently, the sculptures of Nicola and Giovanni Pisano, then Giotto's frescoes, the paintings of Taddeo and Agnolo Gaddi, the Chapel of the Magi in San Petronio in Bologna, the polyptych at the Certosa of Pavia, the sculptures of Orcagna. And there were hagiographic writings such as the *Legenda aurea* ('The Golden Legend') of Jacob of Voragine and the *Historia trium regum* ('The Story of the Three Kings') by John of Hildesheim.

A specific cult of the Magi had taken root in Florence in the last decade of the 14th century, and we know that a procession left San Marco on the Epiphany of 1390 in simulation of the Magi's journey, reaching the Baptistery, the place 'appointed' to represent Jerusalem or, more pertinently, its Temple. A platform in the background simulated Herod's Palace. After the encounter of the priest-kings with the cruel tetrarch of Judaea, their offerings to the Infant were represented, followed by the Massacre of the Innocents, with "imitation babies".[7] A chronicler of the time wrote that "the Magi processed all over the city, beautifully dressed and mounted, with a large retinue and many novelties".[8]

Since the beginning of the 15th century the members of a 'Compagnia dei Magi' used to meet in the Dominican church of San Marco. Their object was to prepare festiv-

Above, the three scenes telling the story of the Magi in the cycle of the *Life of Christ* (Florence, Baptistery of San Giovanni, mosaics of the vault). The third scene, the *Return Journey of the Magi* (fifth register, north-east segment), shows the three kings sailing home in a boat, according to a different iconographic tradition from the one followed by Benozzo in Palazzo Medici. The work of an unknown artist from the workshop of the so-called Master of the Magdalen, this mosaic probably dates from the years 1275 to 1300.

ities in honour of the Magi every three years, and even the city government made a financial contribution. This was one of those companies whose specific task was to organise convivial occasions, just as the 'Compagnie di quartiere' (recorded from the time of the Duke of Athens, when the city was still divided into *sestieri*) and the devotional lay companies did. They may well have been sodalities for the common people, at a time when the oligarchic families flaunted their youthful 'brigades', who would amuse themselves by organising tournaments, jousts, *armeggerie* or *pas d'armes*, hunts and dances; but it is likely that their members belonged to different social classes. In 1419 the Florentine government was forced to issue an order against the activities of these sodalities, as they could degenerate into violence and could conceal partisan political ambition. However, such brakes were eased off in 1428, and in the festivities for San Giovanni that year one of the 'Kings' made his appearance, sumptuously attired.

Below: the *Adoration of the Magi* by Lorenzo Monaco, now in the Uffizi, was painted in 1421-1422 for the church of Sant'Egidio. Cosimo Rosselli added the scene of the Annunciation and the figures of Prophets in the cusps.

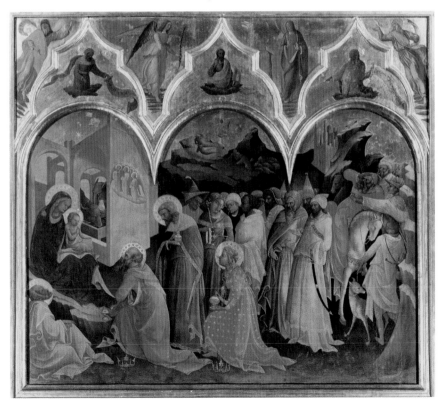

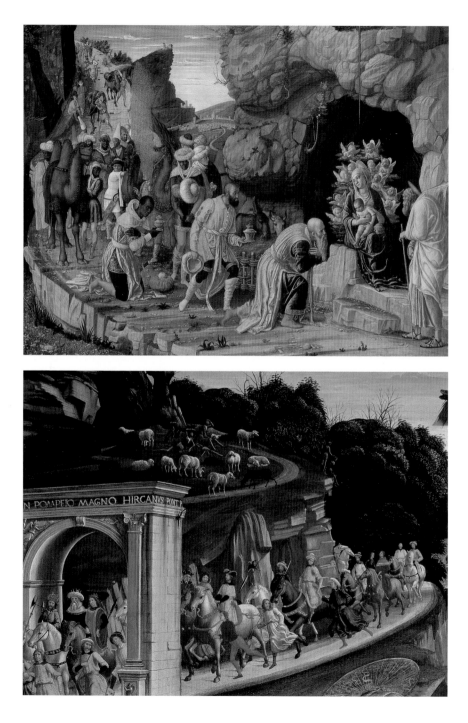

Andrea Mantegna's *Adoration of the Magi* (opposite, above, detail) forms part of a triptych usually dated to the years 1460-1470. Now in the Uffizi, it was probably originally in the chapel of the Ducal Palace in Mantua. The panel painted by Domenico Ghirlandaio in 1485 for Francesco Sassetti, friend and supporter of Lorenzo de' Medici, shows the *Adoration of the Shepherds*: in this altarpiece, made for the family chapel in Santa Trinita and well-known for the presence of Ghirlandaio's self-portrait, the cavalcade of the Magi wends its way across the background (opposite, below, detail). The treatment of landscape is similar to that in other paintings, but the subject and the realistic approach reveal the influence of the Portinari Triptych, painted in Bruges by Hugo van der Goes for Tommaso Portinari, and brought to Florence in 1483.

On the Epiphany of 1429, the cortège of the Magi once again proceeded down Via Larga from the convent of San Marco to the Baptistery, passing under the windows of the Medici's 'old house', situated a little further north of the area where, a few years later, their famous palazzo would be erected.

On his return from his Venetian exile in 1434, Cosimo di Giovanni de' Medici had discreetly but firmly taken up the reins of the city's government. Furthermore, he had established an intense policy of patronage, clearly with the intent of raising greater approval in the city. One of his first actions was to rebuild the convent of San Marco and assign it to the observant Dominicans of San Domenico at Fiesole. It was not by chance that the Dominicans' move to San Marco was ordered by Pope Eugenius IV in January 1436, when the pope, in flight from Rome, had come to see his Medici friend and was staying in the very house belonging to the Ubriachi, outside the San Frediano Gate, where, according to one source, the Magi convened. The indication is, however, uncertain and obscure: there may have been a misunderstanding, or perhaps it was mere coincidence. What is certain is that the convent of San Marco, rebuilt by Michelozzo, who then went on to build the palazzo on Via Larga, immediately became a cultural centre equipped with a library, its principal asset being the large collection of the humanist Niccolò Niccoli.

We may safely assume, then, that Cosimo—apart from his undoubted interest in art and his wish to establish a consensus around him, which might take the form of ecclesiastical reform (the observant Dominicans were those of Dominici and St Antoninus, the Archbishop of Florence)—intended to make San Marco a centre of devotion and culture linked to his family, in emulation of what his adversary Palla Strozzi had already done and hoped to do with the Vallombrosan monastery of Santa Trìnita.

There are a number of clues to suggest this. In 1423 Gentile da Fabriano had completed and signed his radiant panel of the *Adoration of the Magi*, commissioned by Palla for the Strozzi Chapel in Santa Trìnita. So at this stage the question of the Magi procession and the Epiphany celebrations, undoubtedly important, was no longer enough. Opinions on the star-gazing priest-kings were fiercely exchanged, and indeed a sharp political conflict ensued. We must remember that the *translatio*, or transfer, of the relics

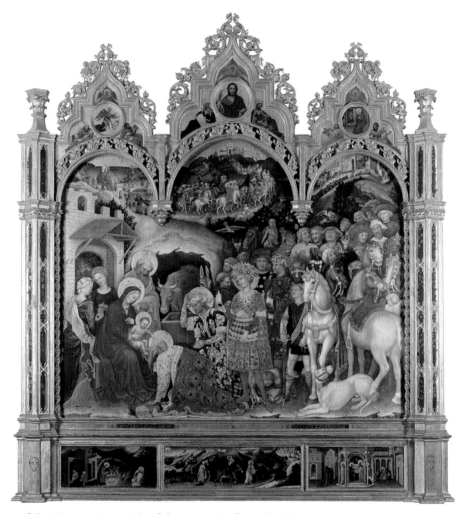

of the Magi, in June–July of the year 1164, from the Milanese church of Sant'Eustorgio to Cologne Cathedral had had deep political significance. Emperor Frederick I, who two years previously had punished the rebellion of the Milanese by destroying their city, meant to humiliate Milan by depriving her of the relics of the Magi, those perfect vassals of the Supreme King. The rebellious city had no right to keep the holy remains of those who represented the submission of earthly powers to celestial ones, a model of the duty of every vassal, who was bound to bow his head before the *corrector orbis*, the *lex animata in terris*, the successor to Augustus and Trajan.

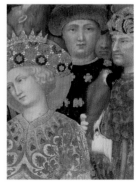

Since then, the Magi became an important piece in the jigsaw of Roman-Germanic 'imperial theology': a sort of keyword of regal cult, an integral part of a discourse aimed at the sanctification of power. After his return to Florence, therefore, Cosimo kept a firm hand on the "choreography of sovereignty"[9] by making himself patron and benefactor of the 'Compagnia dei Magi' and by always sitting on the commission of *festaioli*, or masters of the revels, which was charged with organising the spectacular celebrations.

The Magi were patrons of kings and horsemen,[10] but also of sages, merchants, travellers and pilgrims. The star which had guided and protected them stood out on the insignia of the Innkeepers Guild: one of them, the Magus who had presented myrrh, symbol of immortality, to the Infant, had consequently become the patron of doctors: therefore, no one could be better suited to act, together with St Cosmas and St Damian, as co-patrons of the Medici family. Cosimo wished to lay the greatest emphasis on their feast-day: on the occasion of the Council in 1439, it was celebrated together with that of St John the Baptist. In 1443, Cosimo inaugurated (or resumed) the traditional offering of wax candles that he made in person on visiting the convent of San Marco on the Epiphany. In 1447 it was established that from now on the feast of the Magi would be celebrated every five years in great pomp; the

Opposite: Gentile da Fabriano completed his *Adoration of the Magi* in 1423, and was paid the enormous sum of 150 florins. The altarpiece, originally in the sacristy at Santa Trinita, is now in the Uffizi. Gentile's wealthy patron, Palla di Noferi Strozzi, is portrayed in the centre of the painting behind the young Magus, his gaze directed at the spectator (opposite, below, detail). On this page, detail of the cavalcade in the background.

levying of new taxes was also ordered, due to the Compagnia. The Signoria proceeded to the appointment of a new commission of ten *festaioli* charged with presiding over the celebrations and Giovanni, Cosimo's son, was included. But the head of the family, as we learn from a letter from his wife Contessina to their son, directly took part in the festivities for the 1451 Epiphany. The Captains and Governor of the Compagnia dei Magi were usually strictly trusted liegemen of the Medici household. Never missing at Epiphany celebrations was a prominent member of the Medici family, whose role was halfway between representation and performance. At the 1459 Epiphany, the part of the youngest of the Magi (Caspar, according to the Pseudo-Bede) was played by Piero's son Lorenzo, at that time about eleven years old, the eldest of Cosimo's grandchildren.[11]

In 1496 Filippo Lippi painted an *Adoration of the Magi* (opposite) for the church of San Donato at Scopeto, to replace a picture left unfinished by Leonardo da Vinci around 1480 (below). The painting portrays members of the cadet branch of the Medici family, who commissioned many of the masterpieces – especially works by Botticelli – that have since become associated with the dynasty: behind Pier Francesco, kneeling at lower left, are his two sons Lorenzo and Giovanni, both known as the 'Popolani', or Commoners. Both paintings are now in the Uffizi Gallery.

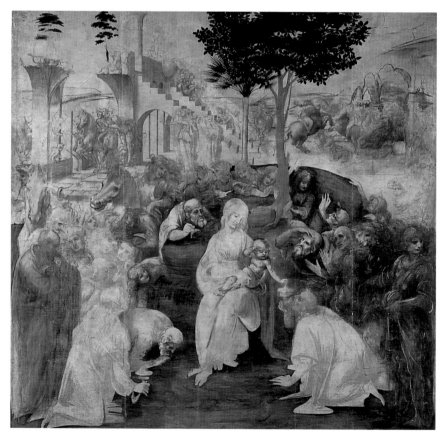

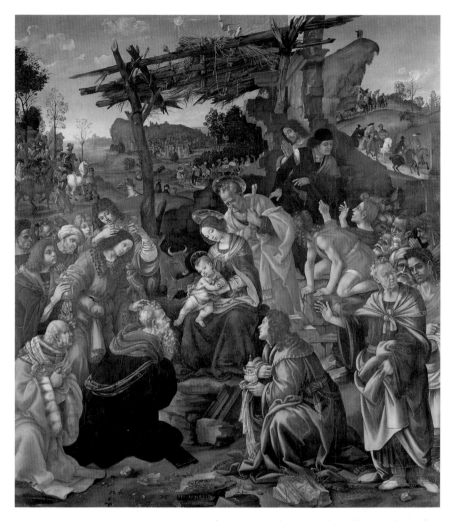

It is worth noting at this point how the Epiphany festivities, increasingly the subject of public legislation, were made public at the same rate as the Florentine Republic was being privatised by the patrons of the 'Compagnia dei Magi', the Medici themselves. As Guarino acutely observes, "the external rites linked to the name of the Magi go hand in hand with the Commune's transfiguration, and express on a celebratory level the progressive identification of state structures and family hegemony. The very manifest nature of this identification induces us to look elsewhere for the persistence of a deeper sense of the sym-

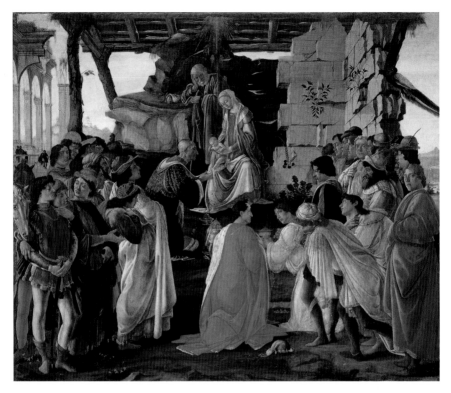

bolic life of the motif of Oriental Kings, of its role in the construction of the elite. Apart from street pageantry, the Magi come under a restrained perspective, where the soldering between hegemony and charisma is not contaminated by institutions and urban spaces, but rather refers to the area of complicity between cult and prestige where no foreign eye dare intrude—almost as if it were a private metamorphosis".[12]

And in the not-so-private semi-darkness of their palace chapel—where they were accustomed to receive distinguished visitors, such as the son of the Duke of Milan— the Medici, still merchants and bankers, in the noble effigies of the priest-kings, were already celebrating the pomp of their 'cryptolordship'. Their advance through the streets of 'their' city on the feast of the Epiphany was also their very own political and family epiphany, their taking possession of their kingdom.

In Sandro Botticelli's *Adoration of the Magi*, now in the Uffizi, Vasari identified the features of Cosimo the Elder (in the centre, turning towards the Child) and of his sons Piero and Giovanni (in the foreground, kneeling). Lorenzo is portrayed in the left foreground as a young man-at-arms, next to Politian and Pico della Mirandola. The fair-haired youth standing on the right is a self-portrait of Botticelli. The painting was commissioned between 1473 and 1480 by Guasparre di Zanobi del Lama, a supporter of the Medici, for his own tomb in Santa Maria Novella. Guasparre's face can be seen in the middleground on the right, looking out towards the spectator.

From Celebration to Fresco

With somewhat tenuous evangelical-canonical support[13] (though enriched by Old Testament echoes and with apocryphal amplifications), the legend of the Magi has conquered the Christian world since the 2nd or 3rd century. The Magi themselves varied in name and number before their relatively late codification, and were portrayed in the Persian costume typical of the worshippers of Mithras and in the traditional act (going back to Egyptian and Assyrian culture) of gift-bearing. Soon taken on in the East in the context of Byzantine Christianity, and developed in the West on the basis of traditions that, at least since the 11th century, accorded them the title and crowns of 'kings', the Magi have constantly aroused the interest of Christian exegetes and artists. Their fame in the West grew thanks to contacts with Asia and, ever since the 13th century, they have been linked to Mongolian culture while—a little lat-

On the right (east) wall of the Chapel of the Magi, a brilliantly coloured cortège accompanies Caspar, the young Magus.

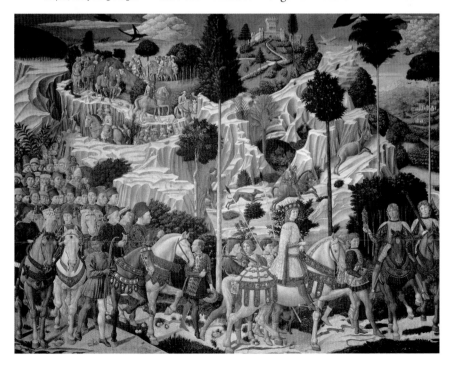

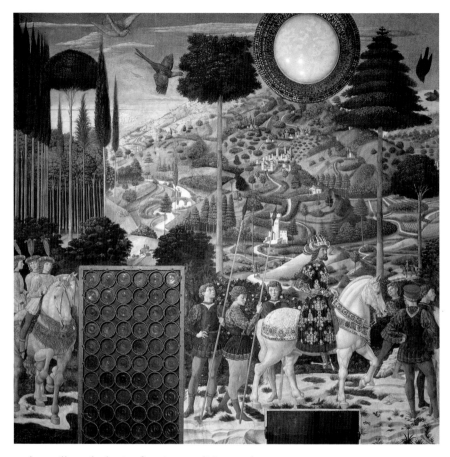

er, but still on the basis of ancient traditions—the repre-
sentation of one of them as an African crept in. Only lat-
er, round about the 13th and 14th centuries, some order
was made in the host of contrasting legendary rumours by
the hagiographic codifications of Jacob of Voragine and
John of Hildesheim—or at any rate a kind of 'vulgate' was
established.[14]

On the end (south) wall, the
middle-aged Magus, Balthasar, is
escorted by lancers and pages.

Through the scriptural texts (the canonical Matthew
and many apocryphal gospels) and the writings of the
Church Fathers, the figures of the Magi were continually
enriched over the centuries with multiple symbolic mean-
ings which, however, rather than ruling each other out,
could perhaps be considered complementary, given the
polysemy of symbols. With their three different ages, the
three Kings were soon to rise to the status of symbols of

the ages of man and also of the various dimensions of cosmic time, and therefore their homage to the Child was seen as an expression of the present (the mature Wise Man), the past (the old one) and the future (the young one) encircling Christ, *kosmokrator* and *chronokrator* ('Lord of the Universe and of Time'). The tradition of their different places of origin being equally early widespread (in opposition to the tradition that all three of them were Chaldeans, Arabs, or Persians—and, later still, Tartars, Indians, or Ethiopians), they became the symbols of the three biblical human races, each of which has one of Noah's sons at its

On the left (west), we see Melchior, the aged Magus. Before him the cavalcade winds out of sight behind the hill.

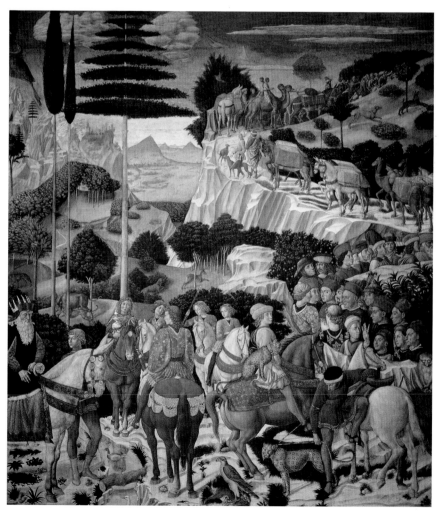

head. Under the profile of political symbolism, perhaps they represented, above all, the three *ordines*, i.e. the three-fold division of society examined by Georges Dumézil and, for Western civilisation, by Georges Duby and Ottavia Niccoli.[15] In this perspective, representing the *oratores* or priests would be the Magus bearing incense, the symbol of prayer; representing the *bellatores* or warriors, the one bearing gold, symbol of worldly power; and representing the *laboratores* or workers, the one offering myrrh, connected with death and eternity, and consequently with the chthonic powers of fecundity and reproduction. In fact, the three gifts received by Jesus are traditionally intended as follows: incense as God, gold as King, myrrh as Man (but, according to another version, also because He is the true and perfect Physician, given the real and symbolic powers of gum resin extracted from the *Comminophora abyssinica*, a preservative against corruption[16]).

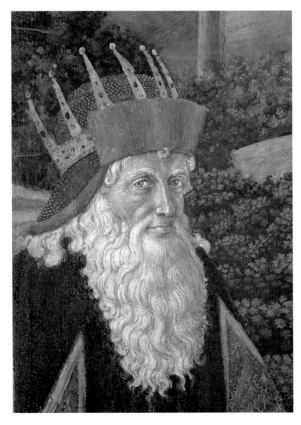

The figure of the aged Magus has traditionally been taken to portray the features of Joseph, the Patriarch of Constantinople, who died in Florence during the Council. More recently, however, it has been said to represent Sigismund of Luxembourg, the Holy Roman Emperor who helped to put an end to the Great Schism by convoking the Council of Constance in 1414. The features and the head-covering of the aged Magus are in fact surprisingly similar to those found in a portrait of Sigismund attributed to Pisanello (Vienna, Kunsthistorisches Museum) and in a fresco by Piero della Francesca (1451), which portrays the emperor as the patron saint of Sigismondo Malatesta in the Tempio Malatestiano in Rimini. Like Jesus entering Jerusalem, the aged Magus rides on a beast of burden; the same mount is used by Cosimo the Elder, who is thus celebrated in this fresco as the champion of Christendom and of the desire of the western world for reconciliation.

A reading of Benozzo's fresco in this latter sense adds to it a fully coherent allure. If we accept the traditional and, one must add, very plausible identifications, then in the elderly Magus riding a mule we could see Joseph, the Patriarch of Constantinople who had come to Florence for the Council but who had died there and had been buried in Santa Maria Novella. He is an excellent representative of the *oratores*: it was he whom the Greek Church could thank for reuniting it with the Latin Church, for however short a time. The mature, dark-haired Magus (*fuscus*, according to the Pseudo-Bede's description) corresponds to the *basileus* John Palaeologus, the Byzantine emperor who, trusting that a Western crusade against the Ottomans would save his city, had desired the union of the two churches and the end of the schism between East and West. Finally, the beardless youth would be the young Lorenzo, son of Piero, perfect as representative of the *la-*

Balthasar, the middle-aged Magus, bears the features of the Eastern emperor John VIII Palaeologus (1390-1448), which are known to us from a medal by Pisanello, now preserved in the Cabinet des Médailles of the Bibliothèque Nationale, Paris.

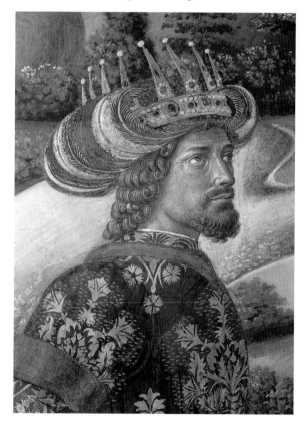

boratores who, in the tripartite division typical of the Middle Ages, should properly be peasants, although in the Florence of the time they could well have been merchants. Unless one assumes a subtler reference to the theme of the bearer of myrrh as a devotee of *Christus medicus*, the healing Messias—a veiled allusion to the Medici surname. As for the name, the head of the youngest Magus stands out against a laurel bush which seems to form a glorious aureole for it: *Laurentius a lauro*. The identification of the three Magi could be regarded as complete, were it not for a recent proposal by Marco Bussagli, who has studied this fresco for many years and who has the courage, rare among scholars, to single out what he considers to be a mistake in his own previous interpretation. Bussagli persuasively argues that the oldest Magus represents not the Patriarch of Constantinople, but the Holy Roman Emperor Sigismund of Luxembourg, who died in 1437. We would therefore have a cavalcade consisting entirely of temporal rulers; and the young Medici (the only one still living at the time

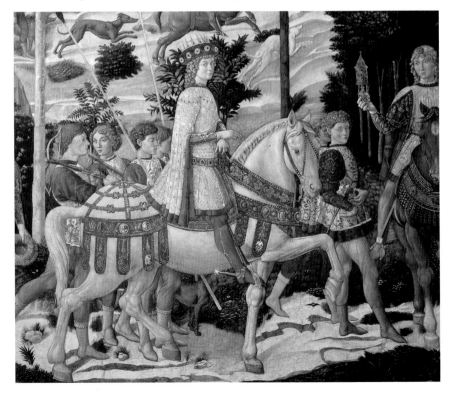

According to Marco Bussagli's interesting theory, Benozzo represented none other than Lorenzo de' Medici – with highly idealised features – between the emperors of the East and the West. The identification of the young Magus with Lorenzo the Magnificent is based principally on the detail of the laurel bush framing the head, but also on the presence in the procession of family members and supporters.

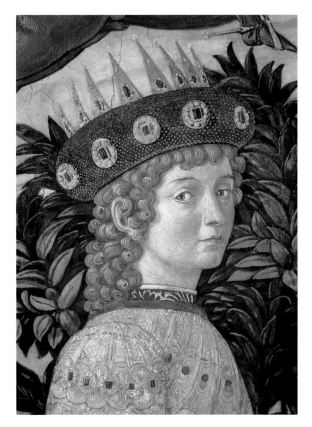

the fresco was painted) would in that case be following the sovereigns of the *pars Occidentis* and the *pars Orientis* of the Empire. The fresco would thus express an explicit candidature for the principate—somewhat daringly for a family of merchants and bankers: a provocative prophecy, even though confined to the walls of a private chapel.

There would seem, however, to be no doubt that Benozzo's *Cavalcade* owes, in differing measures, its symbolic and spectacular[17] layout to three separate occasions. First, the celebrations connected with the Council of Florence in 1439–1442, when the Patriarch of Constantinople, the *basileus* and many picturesque representatives of the Eastern Church could be seen around the city. Secondly, the celebrations for the 'feast of the Magi' characteristic of the Florentine Epiphany, of which the Medici were both patrons and protagonists (up until 1459, the year when Benozzo started on the fresco and when Lorenzo person-

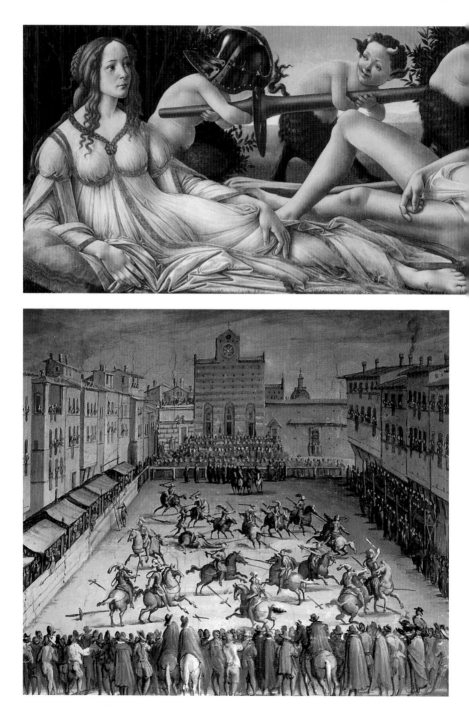

Above, Sandro Botticelli, *Venus and Mars* (London, National Gallery). The interpretation of this work, most recently ascribed to the years around 1483, is still in dispute. According to Ernst Gombrich it was commissioned for the marriage of Simonetta Cattaneo to Marco Vespucci, as is suggested by the nest of wasps (*vespe*) beside the god's head. Left, Giovanni Stradano, *Joust of the Knights in Piazza Santa Croce* (Palazzo Vecchio, Apartment of Eleonora, Room of Gualdrada): this is the scenario where the joust won in 1475 by the young Giuliano de' Medici took place.

ified the youngest Magus). Finally, the festivities—1459 again, in the spring—which Florence dedicated to Galeazzo Maria, son of Francesco Sforza, Duke of Milan, who as his father's ambassador had paid the Florentine allies a visit. The pope—together with the most unruly of his vassals, Sigismondo Pandolfo Malatesta, Lord of Rimini—stayed from 25 April to 5 May in the Dominican convent of Santa Maria Novella. But he did not manage to see Cosimo, immobilised by a possibly 'diplomatic' attack of gout which hindered him from discussing with the pope the matter of the crusade, which he regarded as folly.[18] Neither was this the only circumstance to irritate Pope Pius II Piccolomini during his stay in Florence. The pope complained that, after the notables of the city had scraped together 14,000 florins from among the population to pay him honour, they kept back a large portion of the sum for themselves and another part they used to support Galeazzo and his retinue. Very little money, protested the pope, had been spent on entertaining him; it was not as though the Florentines had splashed out on organising games, although fights between lions and horses, or between lions and other beasts, had been arranged in the piazza, and knightly contests held, during which more wine had been consumed than blood spilt.[19] It was in fact quite normal at this time for chivalric sports, barring accidents, not to be too bloody; as for the pope's complaints, he was known to harbour an inveterate antipathy for the Florentines, and generally to express himself in somewhat caustic terms.

The entertainment organised for the two distinguished visitors was in fact a joust which took place in Piazza Santa Croce on 29 April, followed by a dance at the Mercato Nuovo, a 'hunt' in Piazza Signoria with ferocious beasts and self-propelled devices (among them, a wooden ball containing a man whose task was to goad the wild animals), and finally a banquet in the Medici palazzo on Via Larga, at the end of which one could watch a nocturnal *pas d'armes* from the window. It was held in the street below, sprinkled for the occasion with sand and lit with torches.[20] As one source records, the *messere* or lord, patron, supervisor and protagonist of the *pas d'armes* by night was "the son of Piero di Cosimo",[21] the ten-year-old Lorenzo, who bore a white, red and green banner (the colours of the three theological virtues, often used by the Medici but also by other families) with a device on it bear-

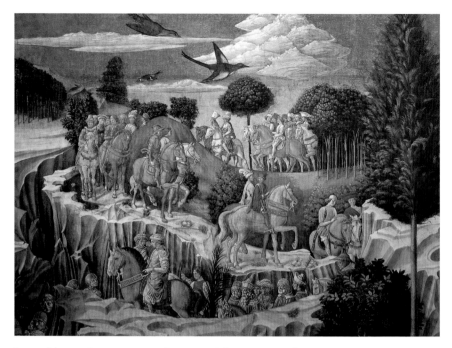

ing *a falcon volant or*, captured in a net. The costume of Benozzo's young Magus has often been identified as the one worn by Lorenzo both for the feast of the Epiphany and for the *pas d'armes* of 1459, essentially because of a few details such as the head-covering, "a beautiful garland fashioned as a *mazzocchio* adorned with flakes of silver, and golden feathers standing erect".[22]

Of course, there is no denying the similarity between descriptions of this kind and many details of Benozzo's fresco—a number of objects cited in Medicean inventories seem to tally, or are in any case very similar. A similarity will also be noted between the young Magus' magnificent costume and the one worn by the same personage in the large altarpiece painted by Gentile for Palla Strozzi. It is not impossible that Lorenzo's 1459 costume did indeed follow that model in certain details. Missing, however, is positive documentary evidence which might enable us to state that Benozzo followed any models faithfully, or that he had decided (or had actually been commissioned) to reproduce in his work not only the effigies of many personages involved in that festive occasion or linked to the House of Medici, but also objects and furnishings.

Above and opposite, two details of the east wall of the Chapel: the long procession following the young Magus, and the landscape stretching away behind him.

PORTRAITS, DEVICES, ALLUSIONS

The cavalcade of the Magi towards the stable at Bethlehem winds, with joyful solemnity, around three sides of the chapel. In the background, the greenery, hills and castles of the Florentine countryside knit well with the craggy rocks of a fairy-tale land and with the presence of animals and plants, markedly allusive and symbolic in content, such as the hunting scenes or the young falcon proud of his prey, which brings to mind the device of Piero, Cosimo's son. Exotic animals, such as the cheetahs on the hunt

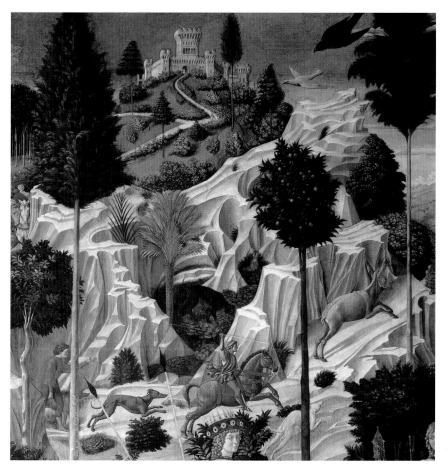

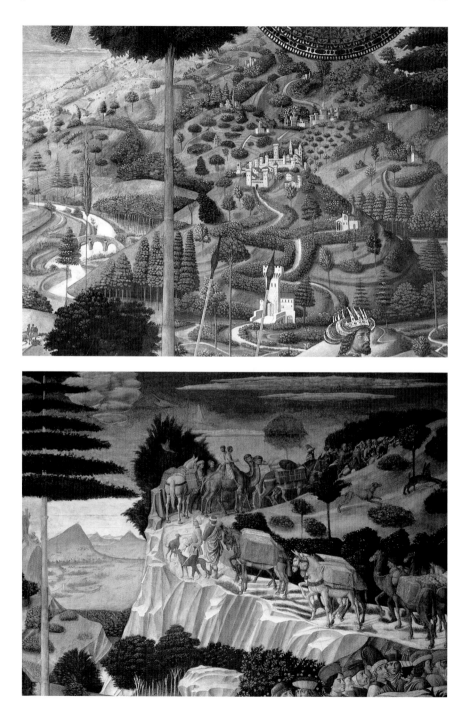

In the procession shown on the west wall there are oriental motifs, such as exotic garments and animals (opposite, below). A more homely atmosphere pervades the landscapes painted in the background on the south wall, where the scattered manor houses are suggestive of the numerous villas owned by the Medici in the countryside around Florence (opposite, above). In the same way, the bird of prey at the feet of the page who precedes the aged Magus (right) recalls a well-known Medicean device, the falcon of Piero the Gouty that grasps in its talons a diamond ring accompanied by a scroll with the motto *Semper*.

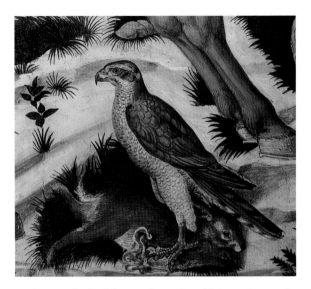

or the camels climbing up the paths which can be seen in the distance and along which the cavalcade is winding its way, call to mind the Orient, vibrant and seemingly close at hand: so does the African servant—in white and vermilion hose, with the green tunic (those colours again!) and holding the Syrian bow—who can be seen in the foreground on the right wall as you face the altar, as well as the head-coverings and accessories of many of the personages.

On the two opposite walls, the beginning and end of the procession are lost in the rugged, tortuous distance of the landscape. Instead, the painter has placed the centre of the cavalcade in the foreground: the elderly king with flowing beard rides a mottled mule; then comes the vigorous, full-grown Wise Man in his splendidly embroidered costume reaching below his knees to emphasise the long straight spurs; and finally the young Magus in a silvery-white tunic. Preceding and following the Magi are two groups of personages, some of them riding mounts, some of them on foot, among whom a few well-known faces are recognisable, or have at least been identified. But the symbolic and allusive character of the work invites us not to overreach ourselves in our attempts at identification, which could lead to misnaming.

At any rate, it looks like "the four eminent positions in the cavalcade following the young Magus on the right

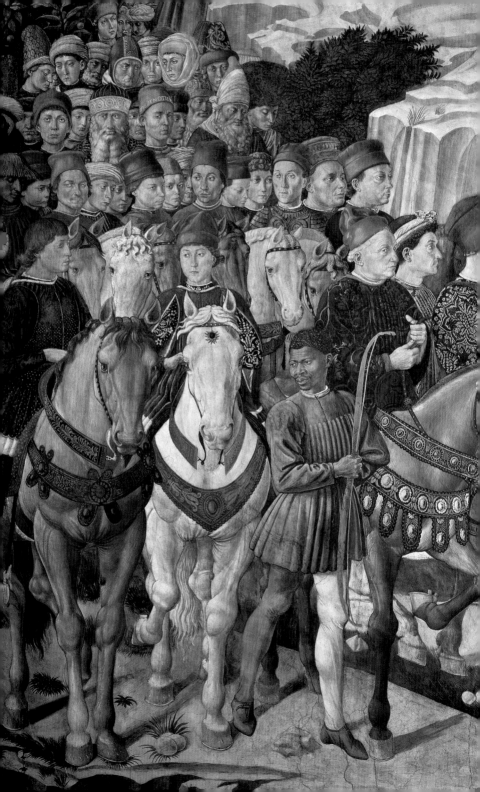

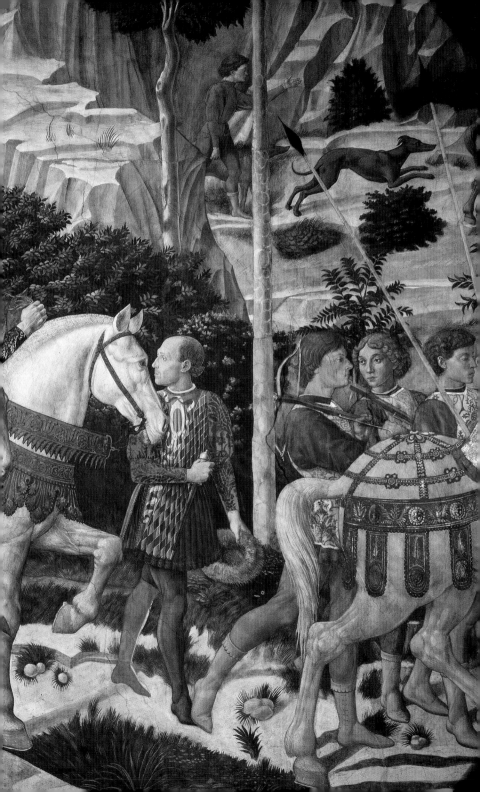

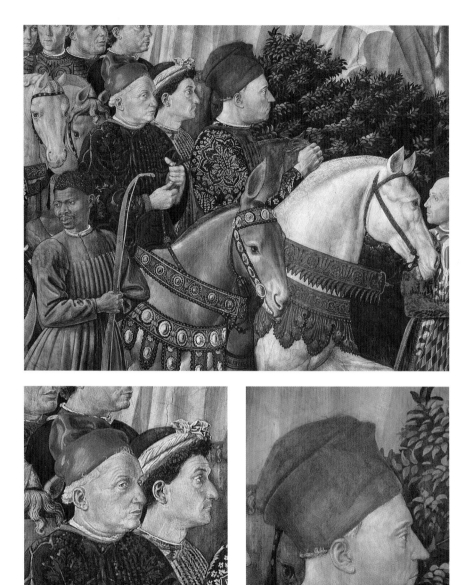

Opposite: the face of Cosimo the Elder, which the celebratory iconography of the House of Medici has made known to us in many portraits, appears next to that of his elder son Piero the Gouty (below, details). While the identification of Cosimo's other two sons – Giovanni and the bastard Carlo, who was born to a Circassian slave-girl and was to become dean of Prato cathedral, where he appears in the fresco cycle by Filippo Lippi – is rather problematical, it is easy to recognise the features of the lord of Rimini, Sigismondo Pandolfo Malatesta, and of Galeazzo Maria Sforza, Duke of Pavia (below). Among the crowded procession there are no doubt portraits (no longer identifiable now, but surely familiar to contemporaries) of the supporters of the House, of the tutors of Lorenzo and Giuliano, and of the scholars who attended the Platonic Academy.

wall are reserved for the patrons and their guests".[23] The white-haired character in the red beret, astride a mule, can be recognised, though not with absolute certainty, as the elderly Cosimo, who was sixty years old when the fresco was begun. On his left is Piero the Gouty, Cosimo's elder son, in a red toque and green brocade with golden embroidery. The man on foot preceding Piero in sumptuous livery has been identified either as Carlo, Cosimo's bastard son (he was born in 1428 of a Circassian slave-girl), or as Cosimo's other (legitimate) son Giovanni. According to Acidini Luchinat, however, there is no conclusive evidence at present why he should be viewed as anyone other than "a member of the Medici clan with organisational and ceremonial duties". Instead, she identifies Carlo in the character wearing a singular head-band on his forehead half-hidden between Cosimo and Piero—a figure until now widely acknowledged as depicting Giovanni.[24] On the left of the family group ride a stern, supercilious Sigismondo Pandolfo Malatesta, portrayed almost in profile, his head bare, astride a superb sorrel, and the handsome adolescent Galeazzo Maria Sforza, his gaze dreamy and a blue and gold jewel dangling on the forehead of his white horse.

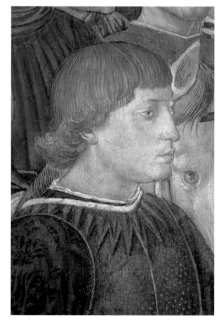

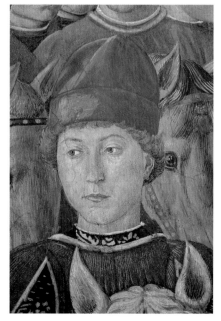

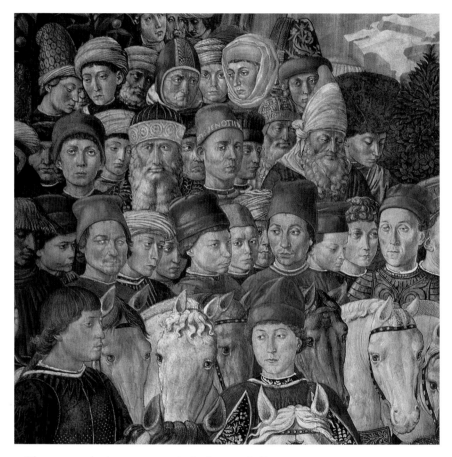

There are no doubt many portraits in the crowd of horsemen following the Medici family and their guests, and among them, recognisable from the words *Opus Benotii* on his red cap, is a self-portrait of the artist. Immediately above him, a recent study has detected in the aged figure at upper left the features of Pius II,[25] whereas below him are probably Lorenzo with his true, irregular features and, a little further to the right, Giuliano in three-quarter view, his gaze cast down in typical fashion. When the fresco was executed, the two would have been aged ten to thirteen and six to nine years old respectively. It is not surprising that Benozzo should have portrayed himself a second time in the group on the wall to the left of the altar, in front of the elderly Magus: indeed, the repetition of a figure within the same work was common practice. Neither is it surprising

In the centre of Caspar's entourage, the first self-portrait of Benozzo is recognisable by the signature on the hat. Lorenzo de' Medici's characteristic profile is discernible in the young man immediately beneath the artist; the boy next to him is often identified as Giuliano, although Cristina Acidini believes that he is the one a little to the right, with bowed head. Two further self-portraits of Benozzo appear on the facing wall (opposite, the first face at top left and the figure in the blue turban with a white band in the centre).

that Lorenzo, idealised and embellished with the artificial good looks—much like a classical mask—of the young Magus, should have been portrayed more realistically in the rank that was his due as a young member of the patron's family. The theory has been discarded that the elegant,

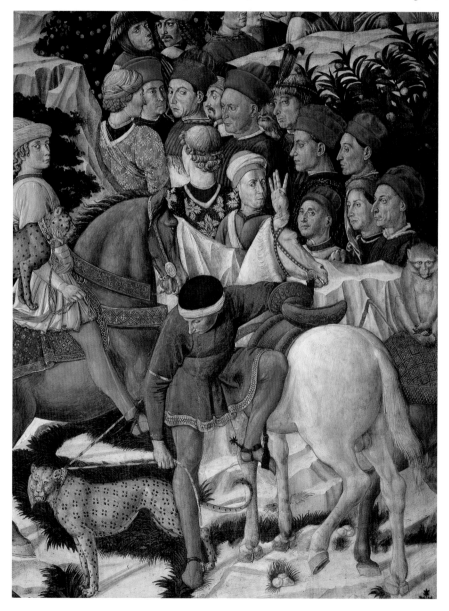

ephebic figures in the retinue following the full-grown Magus are to be identified as the young girls Bianca and Lucrezia, the daughters of Piero the Gouty and therefore the sisters of Lorenzo and Giuliano. Rather, it is thought that Cosimo's wife Contessina de' Bardi, Piero's wife Lucrezia Tornabuoni and the two young girls may be portrayed in the group on the right wall, where family portraits and those of allies and supporters of the Medici evidently form part of the entourage of the young Magus and of the heads of the family. In the laborious, long-running attempts to put names to the portraits in the group, some have recognised Salviati and Ficino, as well as the three Pulci brothers, while, on the left wall opposite, Niccolò da Uzzano, Gino Capponi, Maso degli Albizzi and Palla Strozzi have been recognised among those making way for the elderly Magus. Illustrious and authoritative citizens all of them, of course; but they belonged to a former generation, or in any case one which would have been rather elderly at the time of the fresco, and all of them were to some degree hostile towards the Medici. In this possible opposition between the right and left walls, one could perceive an allusion to Florence's past (the elderly Magus with his attendants chosen from among the oligarchs deprived of power) and future (the young Magus with the victorious *thiasos* of the Medici and their allies), and to the political scenario of the time.[26]

It may be difficult to identify the faces of the personages, the physical traits of whom have been rather doubtfully handed down to us, but the heraldic/emblematic message proceeding from the joyous and sumptuous cavalcade is quite clear. Everything is "fine gold" and "Venetian blue", and the colours are used, as Gillo Dorfles has it, in a timbric manner, in keeping with the straightforward, absolute canons established by heraldry. The House of Medici is glorified in its family insignia—the bezants, familiarly called *palle* ('balls') and present both as such and disguised under various forms, such as the oranges or the round studs in the horses' harnesses[27]—and in the emblems, devices and embroideries (from Paulus Jovius onwards these will be known as *imprese*) that characterise figures and objects, contributing to their identification and, even more, to their role in the context of family glorification.[28]

An initial chromatic/symbolic partition in the parade of the Magi can be discerned in the distribution of the uniforms of the pages and men-at-arms surrounding the three

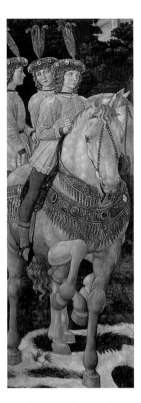

Now that it is no longer believed that Benozzo portrayed Lorenzo's sisters Bianca and Lucrezia as the pages following Balthasar (above, detail), the faces of the Medici women have been sought among the followers of the young Magus, or else in the background of the fresco.

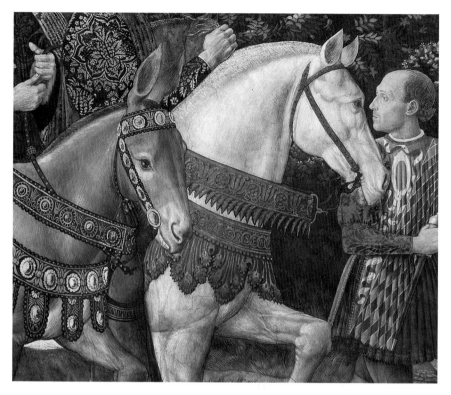

The evocation of Medicean power is made explicit in the fresco by the presence of family symbols, such as the bezants and the diamond ring with the plume and the motto *Semper* on the caparisons of the mounts ridden by Cosimo and Piero, and on the clothing of the page who precedes them on foot.

Kings. The colours dear to the Medici are here repeated: red for the elderly King, deep green for the one in full manhood, and silvery white for the young sovereign. These colours may allude to various things at one and the same time: to the theological virtues embodied by the dignitaries represented (in that case, the green of the Emperor's robes might signify his *hope* of receiving Western aid), to their age (with green for virility and white symbolising adolescent purity), or else to traditional ways of representing the individual Magi.[29] But, so as to avoid any risk of misrepresentation, it must be remembered that, as well as being, along with gold, fundamental heraldic colours, the four colours which are most frequently found in the uniforms of the *Cavalcade* (white, red, green and light blue) were those used in the circus games at Rome and Byzantium. As such they were often to distinguish the various 'brigades' in tournaments and jousts, and they also became the distinctive colours of the four districts into which Florence was divided from the second half of the 14th century.[30]

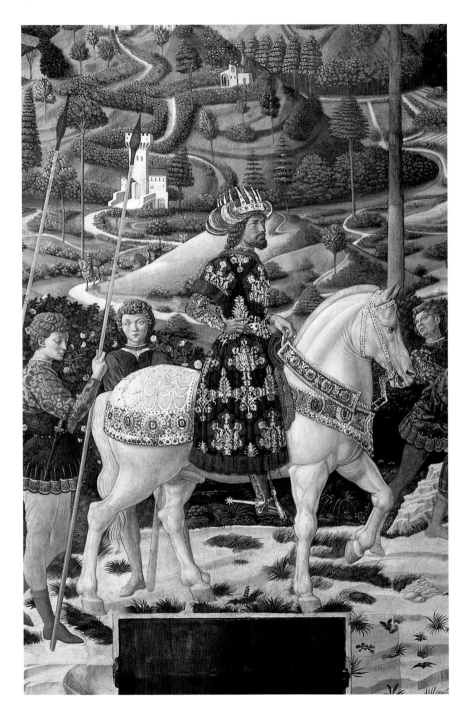

The interplay of insignia and devices is repeated on the harnesses of the horses: the *falsiredini* or rein-covers (strips of cloth or leather concealing the reins) of the personage identified as Cosimo the Elder bear studs alluding to the Medicean 'palle', in alternation with stylised lanterns in gold, which Acidini Luchinat has cleverly linked to a symbolic image.[31] On the other hand, Piero the Gouty's red rein-covers decorated with gold (red and gold are the colours of the Medici arms) bear diamond rings, inside of which are the seven heraldic 'palle', alternating with a motif of three feathers which, at least since the early 16th century, have been securely identified as ostrich plumes.[32] Diamond rings appear again in the harnesses of the self-same

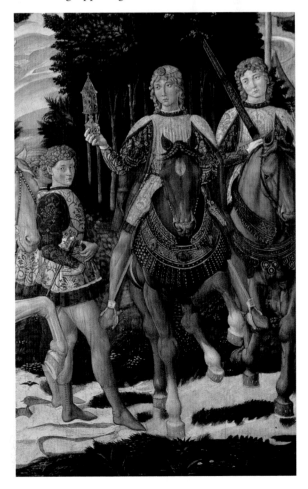

Opposite: the magnificent horse of the adult Magus is possibly based on a bronze horse's head, presumably dating from late Antiquity, which formed part of Lorenzo's collection. Confiscated by the Republic in 1495, after the expulsion of the Medici from Florence, the statue returned to the Via Larga palace in 1512. Since the late 19th century it has been in the Archaeological Museum. Right, the pages of the young Magus carrying the jar of myrrh, the gift with the most complex significance: the balm used to anoint the body of Christ after the Deposition is in fact regarded as an allusion to the thaumaturgic powers of the Messias, but also to his human nature, and to the Passion.

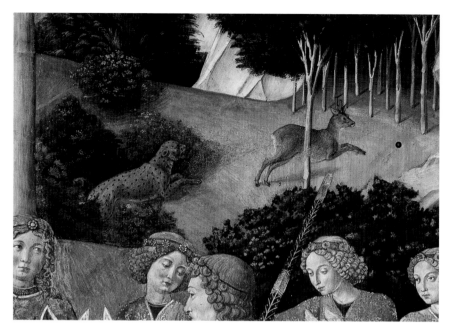

personage's horse, but this time interlinked on the mount's breast-strap, each one of them enclosing a capital letter in gold which composes the motto *Semper* ('Always'). Peacock feathers decorate the fringe on the breast-strap. Golden balls and feathers on a red background are repeated on the young Magus' harness and the ring with a diamond, tied to a ribbon on which the motto *Semper* can be made out, stands out in the fine livery of the figure on foot who precedes Piero.

The harnesses are not only rich but also sturdy, suitable for horses of war; yet the mounts cited here—with the exception of the mules ridden by the elderly Magus and by Cosimo—are all palfreys, vigorous but easy to control. Mario Scalini suggests that the influence of a classical bronze horse's head now in the Archaeological Museum of Florence, which possibly entered the Medicean collection thanks to the *basileus*, can be discerned in the horse ridden by the Magus in full manhood. The apparent docility of their mounts does not deter the two younger Magi from wearing golden, long-necked riding spurs of the 'wheel' or 'rowel' type with eight points. The *stincali* or greaves lined in red leather which are worn by the young Magus are principally for hunting, though they are not devoid of a

Above and opposite, two of the many hunting scenes painted by Benozzo in the background to the procession – respectively on the west and east walls.

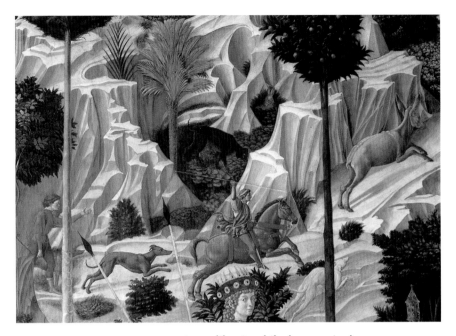

certain warlike air, while the pages in the entourage seem to be wearing *corazzine*, that is to say cuirasses consisting of metal scales or plates fixed to padded canvas and covered with precious fabric, so as to imitate the form of the doublet worn over shirts. These garments were also used in hunting, as were the long thrusting spears or *chiaverine*, the steel crossbows or *frullane*, which slung clay bullets at fowl, and the Syrian bow of the African attendant. The attire of the young Magus is suitable for riding in the hunt: a white leather-covered breastplate (*montanino*) decorated with gold, with a pattern of bat's wings on the chest and scales on the skirts. Like the golden spurs, a thick and richly wrought riding-belt, studded with jewels, is distinctive of one belonging to the knightly class: in other words, it denotes the fact that he had received investiture in the form of the so-called *addobbamento*.

Other details (personages with cuirasses, *epaulières*, *cappelli da campagna* and *cappelline* or caps) remind us that the realistic key to the cortège is that of the hunt, but that this is not to be separated from a warmongering dimension as befits the escort of three kings. We are reminded that they are monarchs by the sword-bearing pages who precede them.[33]

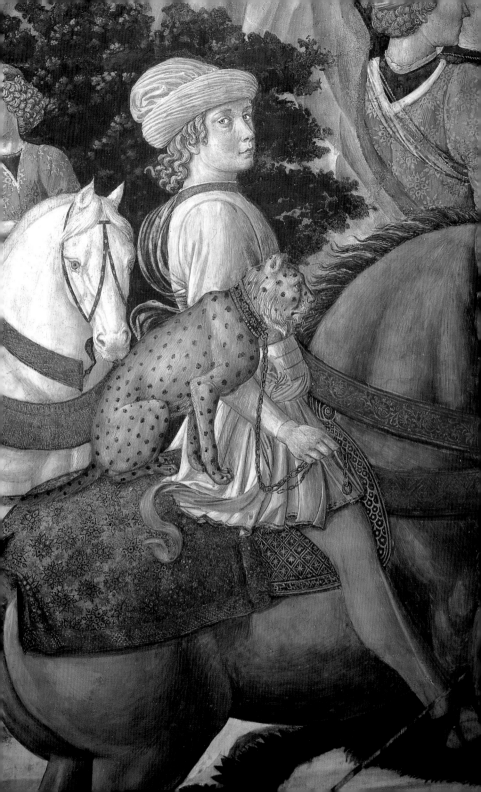

NOT JUST A FABLE

Passing through to the other side of a fresco is no easier than going 'through the looking glass', as Alice did. Behind the layer of beautiful colours and brilliant gold which restoration has brought back to the original splendour, and behind the heraldic, courtly language of emblems, arms and hunting or war attire, lies something mysterious, unfathomable, disturbing. Birds soaring in the sky or depositing their prey proudly on the ground, the green of the trees and shrubs—such as the bay tree serving as a backdrop for the idealised image of Lorenzo, who thus appears haloed by his best-known emblem—joining western forms to exotic ones: behind each image lurks a symbolic message.[34] The characters exchange glances or directly address the spectator; there are also enigmatic gestures, such as that of the man on the left wall, who is clearly indicating the number 5,000 with his right hand, according to the system of finger calculation in use at the time.[35] Beyond the everyday and extraordinary matters that Benozzo blends together employing a pictorial language that still owed a great deal to International Gothic, to which his masters were bound in one way or another, a sizeable amount of the secret significance of the *Cavalcade* still lies concealed under a rigging of undeciphered hieroglyphics, of messages devised expressly to escape the common spectator and challenge those who pay greater attention—understandable by only a few, perhaps even only by the painter and/or his patrons. Perhaps the whole fresco cycle is just one single, giant 'device'.

It may be that a trace of sadness and an aura of disquiet slightly overshadow Benozzo's beautiful colours. His Balthasar, the manly and *fuscus* Magus with his heavy green-and-gold brocade robes lined in fur, had been placed in the sepulchre of the *basileis* in October 1448. If Lorenzo's idealised mask is a classical one, the stern face of John VIII Palaeologus is a funeral mask. Five years after his death and six years before Benozzo took on the walls of palace chapel, Constantinople had already been lost to Christendom, which was still shamed and in mourning even though it immediately set to dealing with the new lord—the Turk.[36]

Opposite: the page who precedes Melchior, the aged Magus, leads the entire procession. Surprisingly enough, no precise theory as to his identity has been proposed by students of the *Cavalcade*.

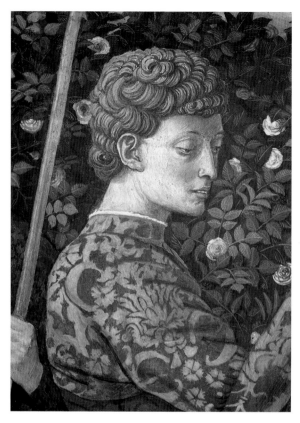

Left, one of the pages escorting Balthasar, the adult Magus, holding the long rods known as 'chiaverine'. Opposite, the young knights preceding Melchior, the aged Magus. The frankincense borne as a gift by the page alludes to prayer and to the divinity of Christ.

Behind the cortège of the Magi following the star direct-ly to the stable of the Infant, there was, perhaps, a distant promise to Pope Pius II, perhaps even remoter plans for a crusade.

But this is not the main reading of the fresco cycle and the message that has been passed down to us. Behind the cheetahs, depicted like big lynxes, and the falcons, the hunts and the towered country dwellings painted in the background, the symbolic trees and the javelin poles; be-hind the analytical and calligraphic attention which proj-ects the Gothic dream of the 'good life' into the middle of the humanistic Quattrocento—behind it all flashes the firm, hard substance of a political message. This vision of fine horsemen venerated as saints on the walls of a chapel, around whom crowd the faces and emblems of a whole family of merchants, certainly belongs to Florence, but it could just as well be situated (*mutatis mutandis* in terms

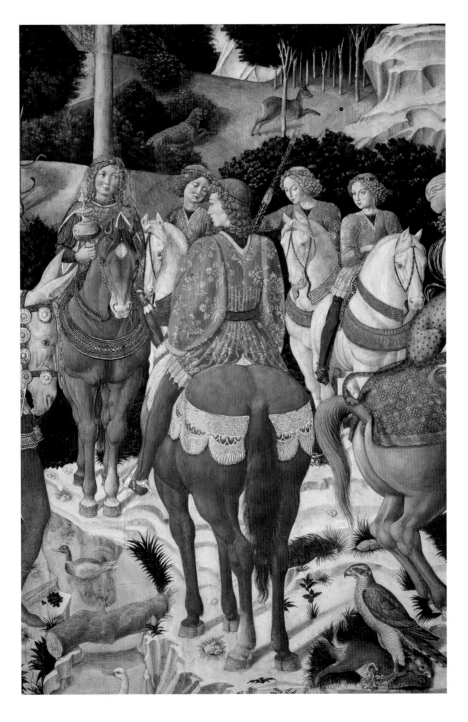

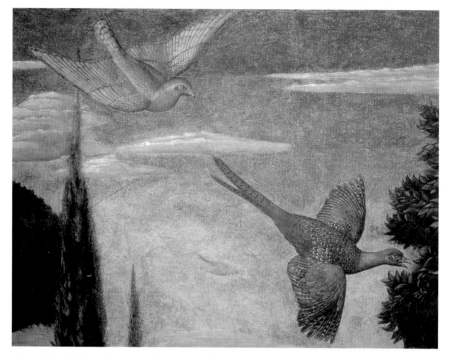

of style) in Milan, Ferrara, Mantua and perhaps even in Naples or, better still, in Dijon or Angers. The Republic of Florence comes to a stop on the threshold of the palazzo on Via Larga. Even though Cosimo, who built it, and Piero, who had it frescoed, were as yet good private citizens (or so they liked to call themselves), the future Magnificent Lord already stands at the ready on his white horse, in his silvery tunic, with his almost crown-like head-gear. It is not by chance that Sigismondo Pandolfo Malatesta and Galeazzo Maria Sforza are close on his heels; friends and allies, indeed, but also political models. In the shadow of the palace chapel, at the foot of the effigies of the three Kings in procession behind the star leading them to the King of Kings, the merchants from Cafaggiolo are already embracing their regal dream.

In the 1469 joust Lorenzo would have his star, too— that of Mars, which he proudly carried on his helmet. This would be a new and more explicit augury of a regality to be conferred with the favour of the heavens and by force of arms, although the nerve-centre of Medici power really lay, as Lorenzo well knew, in gold and diplomat-

On these pages, details of the animals frescoed by Benozzo. The pheasant pursued by a kite (opposite) and the bull attacked by a cheetah (below) are on the south and west walls respectively. The little bird shown on the west wall of the *scarsella* (right) is but one example among the numerous species painted by Benozzo on water, on land and in the skies. The artist's lack of precision in rendering naturalistic details has not however gone unobserved; indeed, some scholars have seen in these small masterpieces more often the results of consulting bestiaries and of the painter's imagination than of careful studies from life. Together with sparrow-hawks, wild ducks, goldfinches, quails, crows, jackdaws, magpies, titmice and turtle-doves we find the peacock, of which Piero the Gouty was especially fond.

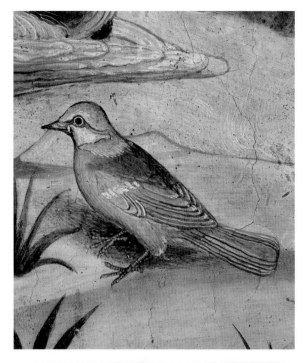

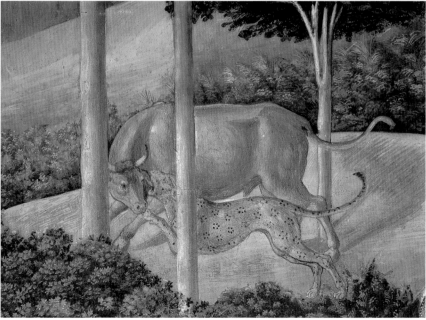

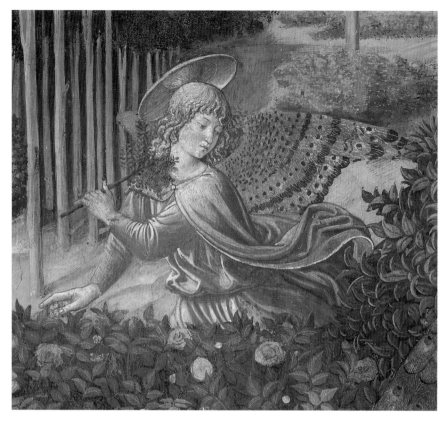

ic skill. Thanks to them Lorenzo would 'reign' in his Florence, albeit as 'cryptolord', until his death in the fateful year 1492, when the New World would be discovered and when Granada would fall—the year we are accustomed to think of as marking the end of the Middle Ages. The death of Lorenzo certainly signalled the passing of an epoch. More than forty years were to go past before the family of Via Larga came back to govern Florence: no longer with the ambiguous powers of 'cryptolordship', but possessed of the ducal coronet, and basking in Imperial favour and in the blessings of the Holy See.

Around the ideal centre of Chapel, consisting of Filippo Lippi's altarpiece of the *Adoration and the Trinity* (opposite), Benozzo depicted the *Adoration of the Angels* (above, detail of the east wall), whereas on the narrow side-walls of the *scarsella*, above the doors leading to the small sacristies, he painted the *Vigil of the Shepherds*.

NOTES

1 On the Via Larga palace, see G. Cherubini and G. Fanelli (eds.), *Il Palazzo Medici Riccardi di Firenze* (Florence: Giunti, 1990), and in particular the essay by Cristina Acidini Luchinat, "La Cappella medicea attraverso cinque secoli", 82–91. Fundamental for a reading of the chapel is C. Acidini Luchinat (ed.), *The Chapel of the Magi. Benozzo Gozzoli's frescoes in the Palazzo Medici-Riccardi, Florence*, translated by E. Daunt and D. Kunzelman (London–New York: Thames and Hudson, 1994), which examines in detail the iconographical complex in the light of the recent restoration and with a wealth of learning. [All references to this work are to the original Italian edition: *Benozzo Gozzoli. La Cappella dei Magi* (Milan: Electa, 1993).] On the legend of the Magi, see F. Cardini, *La cavalcata d'Oriente. I Magi di Benozzo a palazzo Medici* (Rome: Tomo, 1991); id., *La stella e i re: mito e storia dei magi* (Florence: Edifir, 1993); M. Bussagli et al., *I tre saggi e la stella* (Rimini: Il Cerchio, 1999). These works provide the relevant bibliography.

2 Acidini Luchinat, "La Cappella medicea", 82.

3 Lippi's panel is now in the Gemäldegalerie of the Staatliche Museen, Berlin, and has been re-

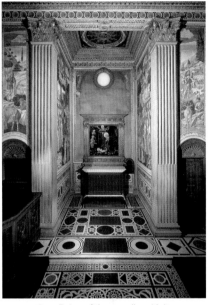

Overall view of the scarsella, with its elaborate marble pavement.

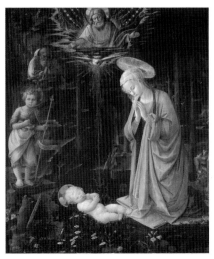
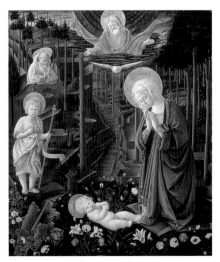

Filippo Lippi's *Adoration*, now in Berlin, and the copy that was substituted for it in the Chapel of the Magi.

placed in the chapel by a copy made, for reasons that are still unclear, by an anonymous 15th-century painter known as 'Pseudo-Pier Francesco Fiorentino'.

4 On the works of Gozzoli, see A. Padoa Rizzo, *Benozzo Gozzoli pittore fiorentino* (Florence: Edam, 1972).

5 Acidini Luchinat, "La Cappella medicea", 91.

6 See L. Berti, B. Bellardoni and E. Battisti, *Angelico a San Marco* (Naples: Curcio, 1965), plate 129.

7 H. Hofmann, *Die heiligen drei Könige. Zur Heiligenverehrung im kirchlichen, gesellschaftlichen und politischen Leben des Mittelalters* (Bonn: Röhrscheid, 1975), links this Florentine display to the procession of the Magi which took place in Milan in 1336. The procession had displayed various kinds of exotic animals and objects; since then it was repeated annually. The initiative, first taken by the Dominicans, passed on to Florence where it became established in the Dominican convent of Santa Maria Novella. See also R.C. Trexler, "The Magi Enter Florence. The Ubriachi of Florence and Venice", *Studies in Medieval and Renaissance History*, n.s. 1 (1978), 129–213 [now in *Church and community 1200–1600. Studies in the history of Florence and New Spain* (Rome: Edizioni di storia e letteratura, 1987), 75–167], where it is suggested that the merchant Baldassare degli Ubriachi (or Embriachi) introduced the cult of the Magi to Florence and built a chapel in Santa Maria Novella to his patron

saint. It seems that it was from the workshop of the same man that emerged the famous triptych of hippopotamus fangs in the Certosa of Pavia (*c.* 1409). It remains unclear whether Baldassare was also an artist, or whether he was more of an art dealer and owner of shops where engravers worked.

8 A. Molho and F. Sznura (eds.), *Alle bocche della Piazza. Diario di Anonimo fiorentino (1382–1401). BNF, Panciatichiano 158* (Florence: Olschki, 1986), 89.

9 R. Guarino, "Introduzione", in *Teatro e culture della rappresentazione. Lo spettacolo in Italia nel Quattrocento* (Bologna: Il Mulino, 1988), 31. Guarino confirmed the probable link between the Strozzi altarpiece, the choice of the Magi theme and the entrance into Florence of Pope Martin V on his way from Avignon to Rome, and his stay in Florence between 1419 and 1420. See also D.D. Davisson, *The Advent of the Magi. A study of the transformations in religious images in Italian art, 1260–1425*, Ph.D. diss. (Baltimore: Johns Hopkins University, 1971); id., "The Iconology of the S. Trìnita Sacristy, 1418–1435. A study of the private and public function of religious art in the early Quattrocento", *Art Bulletin*, 57 (1975), 315–334. Guarino also refers to P. Francastel, *La figure et le lieu: l'ordre visuel du Quattrocento* (Paris: Gallimard, 1967), 108–125 (for an analysis of Gentile's *Adoration*), and to M. Dykmans, "D'Avignon à Rome. Martin V et le cortège apostolique", *Bulletin de l'Institut historique belge de Rome*, 43 (1968), 203–308 (for Pope Martin V's retinue).

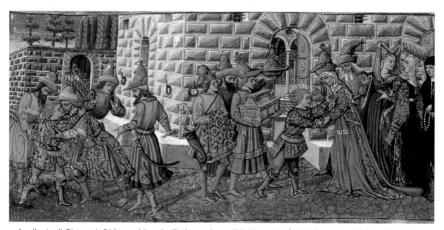

Apollonio di Giovanni, *Dido receiving the Trojan embassy* (BR, Ricc. 492, fol. 74v): in the miniatures illustrating this Medicean codex of Virgil we find the very first representations of the family palazzo on Via Larga.

10 See H. Kehrer, *Die heiligen drei Könige in Literatur und Kunst*, 2 vols. (Leipzig: E.A. Seemann, 1908–1909), ii, 51–53.

11 A fundamental study of the 'Compagnia dei Magi' is R. Hatfield, "The Compagnia de' Magi", *Journal of the Warburg and Courtauld Institutes*, 33 (1970), 107–161.

12 Guarino, "Introduzione", 31.

13 See Matthew 2:1–12.

14 The bibliography on this subject is very extensive. We shall limit ourselves to mentioning U. Monneret de Villard, *Le leggende orientali sui Magi evangelici* (Vatican City: Biblioteca Apostolica Vaticana, 1952); M. Elissagaray, *La légende des Rois Mages* (Paris: Editions du Seuil, 1965); Joannes (John) of Hildesheim, *The Three Kings of Cologne*, edited by C. Horstmann (Millwood, N.Y.: Kraus Reprint, 1988); M. Bussagli and M.G. Chiappori, *I Re Magi. Realtà storica e tradizione magica* (Milan: Rusconi, 1985); F. Cardini, *I re magi: storia e leggende* (Venice: Marsilio, 2000); and, of course, the works cited above. Valuable suggestions for further reading are also provided by the contributions listed in note 1.

15 G. Duby, *The Three Orders. Feudal Society Imagined*, translated by A. Goldhammer [original French edition: *Les trois ordres: ou, L'imaginaire du féodalisme* (Paris: Gallimard, 1978)], with a foreword by T.N. Bisson (Chicago: University of Chicago Press, 1980); O. Niccoli, *I sacerdoti, i guerrieri, i contadini. Storia di un'immagine della società* (Turin: Einaudi, 1979).

16 See E. Maugini, *Botanica farmaceutica* (Florence: Clusf, 1979), 615.

17 On this latter aspect insisted G. Dorfles, "Benozzo Gozzoli", in *Studi Fiorentini*, vii (Florence: Sansoni, 1963), 71–86.

18 See F. Cardini, "La Repubblica di Firenze e la crociata di Pio II", *Rivista di storia della Chiesa in Italia*, 33 (1979), 462.

19 E.S. Piccolomini (Pope Pius II), *I Commentari*, edited by L. Totaro (Milan: Adelphi, 1984), i 365. For an English translation, see *The Commentaries of Pius II*, 5 vols., translated by F. Alden Gragg, with historical introduction and notes by L.C. Gabel (Northampton, Mass.: Dept. of History of Smith College, [1937]–57); an abridged version has been published as *Memoirs of a Renaissance Pope* (New York: Putnam, 1959). Totaro translates *equestria certamina* as 'tournament', also because Pius alludes to the "spilt blood". The Church formally forbade tournaments, although the prohibition, going back to the 12th century, was practically a dead letter by this time. We would prefer 'knightly contests', because the event was really a *pas d'armes*.

20 As for the 'hunt' and the wooden ball device, Benedetto Dei reported that "this exercise came from a Florentine who had seen it in the lands of the Sultan and in Syria": see B. Dei, *La Cronica dall'anno 1400 all'anno 1500*, edited by R. Barducci (Florence: Papafava, 1985), 68. A description of the honours paid to the Pope and to Sforza is in *The "Libro cerimoniale" of the Florentine Republic by Francesco Filarete and Angelo Manfidi*, edited by R.

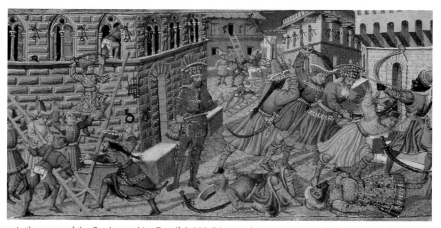

In the scenes of the Greeks attacking Troy (fol. 84r), Priam's palace appears as an idealised version of Palazzo Medici; eastern-style arms, costumes and hairstyles recall the Council of Florence.

Two images from a manuscript of Filippo Calandri's *Treatise on Arithmetic* (BR, Ricc. 2669).

C. Trexler (Geneva: Droz, 1978), 74–77. The joust is described in the anonymous *Terze rime in lode di Cosimo de' Medici e de' figli e dell'onoranza fatta l'anno 1458 al figlio del duca di Milano et al papa nella loro venuta a Firenze* (BNCF, Ms. Magl. VII.1121), an extract of which was published by G. Volpi, *Le feste di Firenze del 1459. Notizie di un poemetto del secolo XV* (Pistoia: Pagnini, 1902).

21 Ser Giusto di Giovanni Giusti d'Anghiari, *Memorie dal 1437 al 1482*, BNCF, Ms. II.II.127, fol. 76v.

22 See André Chastel, *Art et humanisme à Florence au temps de Laurent le Magnifique: études sur la Renaissance et l'humanisme platonicien* (Paris: PUF, 1959; 3rd updated edition 1982).

23 Acidini Luchinat, "La Cappella medicea", 86; see also, by the same author, "Medici e cittadini nei cortei dei Re Magi: ritratto di una società", in *Benozzo Gozzoli*, 363–370, where a number of attributions are clarified and corrected.

24 Acidini Luchinat, "Medici e cittadini", 366.

25 C. Märtl, "Papst Pius II. (1458–1464) in der Kapelle des Palazzo Medici Riccardi zu Florenz. Ein Beitrag zu Ikonographie und Zeremoniell der Päpste in der Renaissance", *Concilium medii aevi*, 3 (2000), 155–183.

26 For these identifications we refer the reader to the extensive bibliography given by Acidini Luchinat ("Medici e cittadini", 369–370), who prudently underlines the hypothetical character of many of them.

27 Many of these horse trappings are listed in the Medicean inventories of 1456 and 1492 (ASF, Mediceo Avanti il Principato, 165). I am grateful to my friend Mario Scalini for placing at my disposal the results of his research into the harnesses and arms of the *Cavalcade*. I am also indebted to Nicole Carew-Reid, Giovanni Ciappelli, Elvira Garbero Zorzi, Lucia Ricciardi and Paola Ventrone for further valuable information.

28 On Medicean emblems, see F. Ames-Lewis, "Early Medicean Devices", *Journal of the Warburg and Courtauld Institutes*, 42 (1979), 122–143.

29 From the mid 13th century the Epiphany ritual (we refer here to that of Besançon) "took on particular pomp, as it was intended by the canons as a scenic game. On this occasion, three canons wore dalmatics: the first was white, the second red and the last black. Each of them carried a palm in his hand and a crown on his head. Servants followed them, offering the gifts in cups": see J. Heers, *Fêtes des fous et carnavals* (Paris: Fayard, 1983).

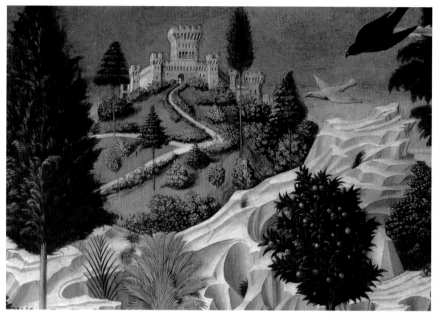

A detail of the east wall of the Chapel.

30 See A. Cameron, *Circus Factions: Blues and Greens at Rome and Byzantium* (Oxford: Clarendon Press, 1976).

31 Acidini Luchinat, "La Cappella medicea", 86–87.

32 The diamond is regarded as a source of life, of duration, of stability; see *L'oreficeria nella Firenze del Quattrocento*, exhibition catalogue (Florence: Studio per edizioni scelte, 1977), 342. To the diamond symbolising eternity and the ring symbolising union (with a pun on *Deo amante*, 'with the love of God'), Piero added the motto *Semper*. The peacock feathers referred to the symbol of eternity and resurrection, while those of the ostrich (believed to be always of the same length) referred to justice. Contrary to Jovius' too restrictive interpretation, F. Ames-Lewis has demonstrated that certain emblems and devices of the Medici were not exclusive to individual members of the family, but were adopted by others as well, though perhaps with a few modifications.

33 For details, and the full edition of the Medicean arms inventories, see M. Scalini, "L'armeria di Lorenzo de' Medici", in *Oplologia Italiana* (Florence 1983), 24 ff., and "L'armatura fiorentina del Quattrocento e la produzione d'armi in Toscana",

in *Guerra e guerrieri nella Toscana del Rinascimento*, essays collected by F. Cardini and M. Tangherini (Florence–Pisa: Edifir, 1990): a transcription of Piero the Gouty's inventory may be found in notes 51, 53 and 60.

34 See M. Levi D'Ancona, *The garden of the Renaissance. Botanical symbolism in Italian painting* (Florence: Olschki, 1977). As regards the palm, pomegranate and other species with a high symbolic significance, see Acidini Luchinat's observations in "La Cappella medicea", 88.

35 Thus in Filippo Calandri's *Aritmetica* (Florence 1491/92), quoted in M. Sander, *Le livre à figures italien dépuis 1467 jusqu'à 1530: essai de sa bibliographie et de son histoire* (Milan: Hoepli, 1942); but see also Acidini Luchinat's exhaustive note in "La Cappella medicea", 89. Regarding gestures in general, see J.-C. Schmitt, *La raison des gestes dans l'Occident médiéval* (Paris: Gallimard, 1990). In some cases the hand gestures refer to the Jewish Kabbala.

36 For the relationship between the fresco and the fall of Constantinople, see U. Mengin, "La chapelle du palais de Médicis, à Florence, et sa décoration par Benozzo Gozzoli", *Revue de l'art ancien et moderne*, May 1909, 367.

Abbreviations

ASF	Archivio di Stato, Florence
AOSMF	Archivio dell'Opera di Santa Maria del Fiore, Florence
BML	Biblioteca Medicea Laurenziana, Florence
BN	Bibliothèque Nationale, Paris
BNCF	Biblioteca Nazionale Centrale, Florence
BPH	Bibliotheca Philosophica Hermetica, Amsterdam
BR	Biblioteca Riccardiana, Florence

MEDICEAN SYMBOLS
'BALLS' AND EMBLEMS IN THE 15TH CENTURY

by Lucia Ricciardi

After they emerged from faceless anonymity as a result of the fortune they had amassed from their financial, economic and entrepreneurial activities, the Medici, like most families who had likewise risen in the world, hastened to avail themselves of those symbols (chivalric dignity, armorial bearings) which would confer on their house an image of prosperity and grandeur. In keeping with heraldic custom, they chose *propria authoritate*,[1] i.e. freely, the armorial bearings—*or, six bezants gules*—which would represent them in Florentine society.

Without vaunting any official title, the Medici were *de facto* lords of Florence. Cosimo di Giovanni di Bicci, in particular, having been banished by the oligarchy, returned to the city with the support of the entire people, who raised him *ad honorem* to that dignity. Despite this recognition, Cosimo preferred to remain a private citizen and rejected exaggerated greatness and the luxury of courts; he liked to operate at a distance, behind the scenes of that political stage where he was the undisputed protagonist. He did not get rid of the past in order to make way for the present: he retained the republican magistratures, although they were emptied of all power, and he nursed no ambition to create either a court or a city in his own image, a Medicean city.

The various repairs and improvements carried out in Florentine territory during the 15th century, and the attention devoted to the architectural and financial renewal of certain churches and convents, make one think not so much of a desire to transform the face of the city and stamp it with the family name, but rather of a more intimate and reserved wish to carry out certain ambitious family projects. The displaying of heraldic insignia and other symbols on every corner of the city did not only respond to an aesthetic taste, but constituted also an ingenious use of visual expression to indicate political ties and dependencies, to show the community the successes achieved and to enjoy them. When questioned by a lay-brother of the Badia Fiesolana—"for what reason did he place so many balls on all the sides of the monastery, which were many hundreds of thousands"— Cosimo replied with a smile: "So that after my death they may bear witness to the great love I had for you".[2]

Presumably not even the ingenuous lay-brother believed in Cosimo's good intentions and great Christian piety; the mania for setting up heraldic insignia in religious places, both inside and outside the city, expressed the desire to exercise there a kind of *de facto* patronage, and was a clever way of increasing one's own political influence and of cementing alliances. In the church of San Lorenzo, for example, the families which acquired the patronage of chapels were all supporters and allies of the Medici. Cosimo's secret design

Medici coat of arms (Badia Fiesolana).

Medici coat of arms (San Lorenzo).

was undoubtedly to make San Lorenzo "an alternative ecclesiastical pole, in competition—at least initially—with the official one represented by the cathedral".[3]

If only for the simple fact that they were so visible (and most often placed high up, in central and dominant positions), the Medicean heraldic insignia became a constant feature in the daily life of 15th-century Florence. The Florentines of the period referred to them familiarly as *palle* ('balls'), because they were round, obviously; but the heraldic term for them is roundles; and, more specifically, bezants. Whether with love or hatred, they were recognised by everybody and were associated with the greatness of the Medici; they were the symbols of unity, of security, of strength and power—and above all they were a sign of political recognition. Those who shared the political aims, strategies and choices of Cosimo and his heirs were known as 'Palleschi'.

The military power of these partisans is clearly expressed in a chronicle of the time which records the critical episode of the Pazzi conspiracy: in desperation at the bloody events of that April day in 1478, the crowd, involuntary witnesses to the murder of Giuliano de' Medici and the attack on Lorenzo, rushed through the streets of the city in a state of high excitement and terror, scream-

ing "Palle, palle, palle!" In the following days the more hardened partisans, seeking to dig out the aggressors and all their accomplices, spread panic throughout Florence: in every quarter of the city the cry went up, "Palle, palle per amor di Lorenzo!" ('Balls, balls for the love of Lorenzo!').[4]

The link which united Florence to Medicean symbols has not entirely disappeared: it still lives in popular tradition, in old saws and rhymes. With its obvious innuendo, the chant "Palle, palle, palle rosse e gialle" ('Balls, balls, red and yellow balls') sung by boys to a rhythmical military-style tune lasted almost down to our own time, preserving in the popular memory the symbolic value attributed to the insignia and heraldic colours of the house of Medici.

To make up for the lack of a glorious past and a heroic ancestry, the Medici attempted to link their own name to legendary characters and stories. Thus it was that fantastical accounts of the origin of the Medici arms soon began to circulate. According to one of these tales, the supposed founder of the family, Averardo (or Everardo), a proud warrior in the Carolingian army at the time of the Lombards' expulsion from Tuscany, engaged in single combat with the giant Mugello, who lived in the region which was later to be named after him. It was this legendary encounter that gave rise to the Medici coat of arms: the roundles were the heraldic version of the bashes made by Mugello's iron mace on Averardo's golden shield. According to another story, the 'palle' represent the cupping-glasses applied to the wounds of the emperor Charlemagne by a physician, the ancestor of the Medici. When the number of roundles on the shield was eleven, another tale identified them as the heads of eleven enemies decapitated by an unidentified member of the family.[5]

Other theories were produced in the late 19th and throughout much of the 20th century. Some scholars thought that the Medicean heraldic insignia represented oranges or apples—the forbidden fruits of the garden of the Hesperides[6]—while others took

Arms of the Moneychangers' Guild (from Jacopo di Cione's *Coronation of the Virgin*, 1372).

them for medicinal pills, in allusion to the family's name.

Today the most widely accepted explanation is that this insignia originated as a *brisura*, that is to say a variation—in this case relative to the tinctures—of the arms of the Arte del Cambio, the Moneychangers' Guild (*semé of gold bezants on a field gules*).[7] Since many members of the family joined that corporation, the explanation would seem to be plausible. According to Luigi Borgia, however, it is very rare in Italian heraldry for the arms of corporations to be used by private families, and when indeed they are, they have not been altered; moreover, the *brisura* is not a common procedure in Italy, and especially in Tuscany. Borgia sees the 'palle' as one of the simplest heraldic devices, and above all one of the most common—perhaps because of their simplicity, I would add—among Florentine coats of arms.[8]

Without simplifying or undervaluing the content value of the Medicean insignia, Borgia maintains that the choice of the charges was conditioned by the actual construction of the shield itself. The *guigge* (the leather straps which attached the shield to the horseman's left arm) were fixed with screws that passed right through the shield: to cover the bosses on the front, the armourers used all kinds of materials, and it is probable that the

shape of these covers was circular. We should remember, however, that to the collective imagination of the age the 'palla'—or rather the circular form in general—signified notions which could easily be grasped even by the most uneducated. It alluded to the idea of wholeness (in classical iconography the emperor holds a globe in his hand) and of eternity (for the circle has no beginning and no end), but also to the idea of mutability and of the sudden changes of Fortune, the fickle goddess who today raises us to a glorious destiny and tomorrow casts us into adversity. Balls could therefore symbolise precariousness: a most suitable notion in reference to merchants, who put their own lives and goods at risk every day.[9]

The Florentines knew that the ball had a symbolic significance, and the context in which it appeared did not alter this meaning or give rise to misunderstandings. Already by the second half of the 14th century we find attempts to extend and develop the ar-

Medici coat of arms on the tomb of Cosimo the Elder (San Lorenzo, crypt).

Medici coat of arms (crypt of Santa Reparata).

morial bearings: there are two interesting examples of this among the tomb-slabs in Santa Reparata. On Giovanni de' Medici's tomb there is a pointed shield with six bezants, surmounted by a helm with a ball for a crest, in its turn surmounted by a plume of feathers.[10] On the other, belonging to an unidentified member of the family, a shield *à bouche* with six bezants is surmounted by a helm with a crest consisting of a ball grasped by a lion's foot, possibly alluding to the Florentine lion, or Marzocco.

The number of balls on the shield or 'field' varied from a minimum of three, as on the key-stones of the vaults in the transept of the Badia Fiesolana, to a maximum of eleven, as we see in a miniature in a manuscript in the Laurentian Library, Florence;[11] only in the later 15th century does the number of balls become fixed at six. In Florence and the surrounding area it is possible to find many examples of this variability. The cloister of San Lorenzo, for example, has shields of various forms with six, seven or eight balls.

This variation in the number of the balls has been interpreted by Roy Brogan as an expression of the desire of individual members

Medici coat of arms with eleven balls, from a manuscript of the commentary to Aristotle's *De anima* by the physician and philosopher Niccolò Tignosi da Foligno (BML, Plut. 82.17, fol. 3r).

The three golden fleurs-de-lys on an azure field of the kings of France, from the title page of Ugolino Verino's *Carlias*, dedicated to Charles VIII, *ante* 1493 (BR, Ricc. 838, fol. 4*r*).

of the family to personalise their coat of arms, so as to make of it their very own 'emblem'. According to this American scholar, the arms of Giovanni di Bicci had eight bezants, and those of Cosimo six; Piero the Gouty chose the same number of balls as his father Cosimo, and Lorenzo the Magnificent one more, i.e. seven.[12] Passing over the value and symbolic significance of these numbers (all of them, and especially the number three and its multiples, have many), the explanation for this diversity is to be sought in the origins of the Medicean arms.

It is probable that initially the Medici chose for themselves a shield charged with an unspecified and variable number of bezants. Later, following a characteristic heraldic procedure, the number was reduced, but still not fixed. Examples of this very tendency can be found in royal heraldry: the arms of the kings of England—*gules, three leopards passant gold*—settled on the number three and the position 'passant'[13] in the late 12th century; those of the kings of France reduced the number of golden fleurs-de-lys (on an azure field) to three in the 1380s.

In 1465 the Medici were granted by the French royal house the use of the three golden fleurs-de-lys on an azure ground. Louis XI acceded to their request "on account of the familiarity between us", as Lorenzo the Magnificent wrote,[14] and—perhaps more to the point—because of the constant financial and diplomatic relations that united the Medici to the French crown. Visible in numerous paintings and sculptures, the three golden fleurs-de-lys were added to the coat of arms at the point of honour (the 'middle chief'), on an azure ball.[15] According to Luigi Borgia, however, this modification took place somewhat later. It is probable that originally there was not another ball, but a small escutcheon, upside down. The need to harmonise the charges on the shield may well have led to the original grant being altered by the Medici themselves: thus the escutcheon was changed into an azure bezant charged with three golden fleurs-de-lys.[16]

As Bartolo da Sassoferrato maintained in his *Tractatus*, such royal grants were tit-for-tat exchanges: the prestige of the grantees was increased in the eyes of the community, while the royal granters obtained confirmation of their own authority and, probably, cash, since concessions of this kind were almost certainly paid for. The privilege not only made the recipients very proud—it also distinguished their arms from those of lesser families, at a time when the use of insignia was suffering from a kind of inflation. The honour granted by Louis XI represented for Piero and Lorenzo royal recognition of their political stance, their success and the prestige they enjoyed in Italy and abroad. But, as Borgia emphasises, the letter of privilege[17] makes it clear that the French king was merely satisfying the vanity of the Medici, without conceding to them any political title or institutional commission which might authorise them to assume the lordship of Florence.

So, to the extreme simplicity of their family arms the Medici added the fleur-de-lys, or lily. Used as a decorative motif in every age and in every place—from Mesopotamia to Mycenae, from Egypt to Sassanid Persia—this flower seems always to have symbolised royalty. What's more, in the early Middle Ages the lily acquired Christological and Marian associations, and it is frequently encountered in representations of the Annunciation and of the Nativity.[18]

Renaissance humanism, however, exerted its influence even on long-established symbolic systems, introducing alterations. As regards form, humanist culture encouraged heraldry to go back over the most characteristic phases of its own history and to come to terms with the new stylistic requirements: an example of this is the creation of a special octagonal shield known as *a testa di cavallo* ('horse's-head shield', also called simply 'Italian shield'), able to bear all the usual ordinaries (chief, fess, bend, etc.) while at the same time harmonising with Renaissance architecture, which was intent on breathing new life into classical modules. Wherever stylistic difficulties proved insuperable, the charges were detached from their usual context and used as decorative motifs on objects, clothes and buildings, and in illuminated miniatures.

While retaining its own significance, the ball could easily be combined with other symbolic expressions. In a miniature in a codex containing a commentary on Juvenal and dedicated to Lorenzo the Magnificent, for example, an illuminated capital is filled with an elegant interweaving of the diamond ring—Cosimo's personal device—and two leafy branches, from which seven red balls hang on fine threads. In another miniature in the same manuscript there are music-making satyrs surrounded by balls dotted here and there: some on the ground, others hanging from threads, others grasped in their hands as weapons by the satyrs themselves.[19]

This detaching of heraldic charges from their customary context marks an important development, a turning of the language of

Medicean tomb-slab (San Lorenzo).

heraldry, which until then had tended to be a mark of family or group solidarity, towards a more intimate and personal expression, suited to a culture which attributed such high importance to the individual: thus there came into being the *insegna*, a device combining an image and a motto.

Codified in precise rules in the 16th- and 17th-century treatises, the *insegna* had earlier enjoyed wide popularity in embroidery, representing the basic element in a symbolic language created and developed at princely courts, and understood by all those who moved in such splendid circles. It managed to mitigate the age-old debate about the supremacy of the figurative over the literary arts: the *insegna* put an end to it, at least in part, and set up a bridge between poets and painters, who were constantly at war with one another, allying them instead in the creation of original and sometimes very complex enigmatical games.

Among the scholars who occupied themselves with devising rules for the formulation of these mental puzzles was Andrea Alciati, who together with Paulus Jovius (Paolo Giovio) laid down the principles which were to

govern the devising of emblems for centuries. Jovius insisted especially on a just proportion between the "body" (image) and "soul" (motto) of an emblem; Girolamo Ruscelli, on the other hand, took upon himself the task of restricting the number of words, colours and images that might be used, and of limiting the places in which emblems might be displayed.

The great poet Torquato Tasso, the author of the heroic epic poem *Gerusalemme Liberata* ('Jerusalem Liberated', 1581), was also interested in these word-and-image games: he was one of those who held that the vitality of the *insegna* derived from the magic concealed within the tales and wisdom of ancient Egypt.[20] The content and language of the *insegna*, in fact, probably derive from the theological-type symbolism of the medieval bestiaries, herbals and lapidaries, but its success and promulgation were due to the Neoplatonic culture, which had recovered a number of late-Hellenistic and Hermetic writings, whose emblematic language dated back to Alexandrian Egypt. The attraction exercised by this most mysterious of lands was responsible for the diffusion of texts such as Plutarch's *De Iside et Osiride* (which would influence Pintoricchio's fresco cycle in the Borgia apartments in the Vatican) and for travellers' fascinated accounts of hieroglyphics and the pyramids. In 1419 the text of Horapollo's *Hieroglyphica* was discovered on the island of Andros. This work, ascribed to a master of one of the last pagan schools in 5th-century Alexandria, had originally been written in the Egyptian language, and was later translated into Greek by a certain Philip.[21]

As well as being a balanced creation, the *insegna* must have been an extremely personal and changeable form of visual expression, as indeed are the plans and schemes of each one of us. To understand the dynamics of this strange combination of word and image it may be useful to examine the emblem assumed by Maso degli Albizzi—an emblem which he added, somewhat unusually, to his own coat of arms as an additional charge. Following the unfortunate events which saw the involvement of Piero di Filippo degli Albizzi in a conspiracy against the Republic, Maso swore to avenge the wrongs suffered by his family. His plans for revenge were expressed in symbolic terms: shortly after the event Maso took as his emblem a mastiff, its jaws enclosed by a muzzle, as though awaiting the moment of its release. When eventually the suspicions regarding the authors of the conspiracy turned into certainties, Maso changed his emblem: the mastiff appeared with open jaws, as though ready to challenge anyone, and thus it remained.[22]

The unusual feature we just noticed about Maso degli Albizzi's emblem—i.e. the fact that it was added to his coat of arms—is perhaps to be seen as part of a transitional phase, an attempt to combine traditional heraldic language with the *insegna*.

There are other interesting instances of this mixture of languages. One example is a 15th-century miniature from the school of the Sienese master Ser Sozzo Tegliazzi now in the Laurentian Library, Florence: a shield *à bouche* with a gold ground, charged with six balls (one–two–two–one, the upper one azure and with fleurs-de-lys), is surmounted

Coat of arms of cardinal Giovanni de' Medici, from a manuscript of Marsilio Ficino's *Prohemium in Iamblicum* (BML, Strozzi 97, fol. 12r).

Coat of arms of Giovanni, elected pope under the name of Leo X, from the title page of Niccolò Valori's *Vita Laurentii Medices* (BML, Plut. 61.3, fol. 3r).

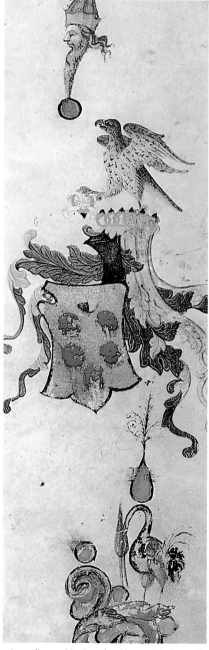

by a helm covered with long green leaves, surmounted in its turn by a crown with six interlinked diamond rings. Above it rises a falcon, clutching in its talons another diamond ring with a fluttering scroll bearing the motto *Semper* ('Always').[23]

Two delicately and very finely illuminated works are by Francesco d'Antonio del Chierico, whose exceptional skills were no doubt highly esteemed by the patron Lorenzo. The first codex, a copy of Seneca's *De beneficiis*, offers a composite decoration, sober but extremely eloquent in proclaiming itself as personal symbol: a laurel crown, of the type used in antiquity to crown the brows of poets, encloses a *testa-di-cavallo* shield, charged with six balls (one–three–two–one—the upper one azure and with fleurs-de-lys).[24]

In the lower margin of its first page, the second codex, a manuscript containing Bartolomeo Fonzio's commentary to the *Satires* of Persius, shows an elegant and unusual image. Another *testa-di-cavallo* shield similar in shape to the one just described is framed by

A peculiar combination of emblem and device on the title page of a manuscript of Dante Alighieri's *Commedia* illuminated by the workshop of Sozzo Tegliazzi (BML, Plut. 40.3, fol. 1). Right, the full page.

two branches of a laurel tree which join together in the upper part of the design; the joining is sealed by a diamond ring with a horizontal scroll bearing the motto *Semper*. In the lower part, two putti beside the trunk seem to be enjoying the shade provided by the leaves and are playing with the lower branches.[25] This is a clear allusion to the Tree of Life that grows in the centre of the garden of Paradise, at the very heart of the Cosmos, where heaven and earth intersect. Because the Tree of Life is at the centre of the universe, it is immortal, and is therefore used as the model for all genealogical trees. In this miniature the coat of arms and the diamond ring at the top of the branches evidently represent the Medici descendants.

In the absence of a personal emblem, very often the members of a family made use of the same device, possibly introducing some modification to the design or adding a personal reference. The diamond ring and the scroll with the motto *Semper*, for example, belonged—according to the most reliable

Medici coat of arms, from a manuscript of Seneca's *De beneficiis* illuminated by Francesco di Antonio del Chierico (BML, Plut. 76.37, fol. 1).

sources—to Cosimo the Elder, although they were continually used not only by his son Piero but also by his grandson Lorenzo, and then by Lorenzo's heirs, especially by Giovanni (the future Pope Leo X), as is well attested by some glazed terracottas by Luca della Robbia the Younger.[26]

Medici coat of arms, from a manuscript of Bartolomeo Fonzio's *Commentary* to the *Satires* of Persius, illuminated by Francesco di Antonio del Chierico (BML, Plut. 54.23, fol. 1).

The diamond (Italian *diamante*, alluding to the motto *Deo amante*, 'With the love of God') and the motto *Semper* both expressed the hope that divine favour would last eternally: 'with the love of God, for ever'. According to some authorities, already by Cosimo's time the diamond ring encircled two ostrich or falcon feathers, as can be seen in the reliefs on corbels in the cloister of the Badia Fiesolana and in those in the ground-floor rooms of Palazzo Medici in Via Larga (now Via Cavour).

Others attribute to Lorenzo the device of the three feathers: red, green and white.[27] As Jovius pointed out in his *Dialogo* (1555), these colours represent the three theological virtues: green for Hope, white for Faith (which is pure), and red for Charity (which is ardent).[28] In fact, other sources testify to the presence of the three feathers before Lorenzo's birth, most notably "in the windows on the second floor of Palazzo Medici, on the painted balcony of the lunette with Filippo Lippi's *Annunciation* in the National Gallery in London, and especially in the Chapel of the Crucifix in San Miniato al Monte, dating from 1448",[29] explaining that they were well-known to men of the time, and were recognised even when variants were introduced. Alessandro Segni, for example, mentions a

Luca della Robbia the Younger, Medicean 'ring', c. 1515 (Rome, Castel Sant'Angelo Museum).

deep blue feather instead of the green one:[30] this anomaly is perhaps best explained as a reference to the royal arms of France. Used as a subtle form of deference and obsequiousness, the deep blue feather may be seen as a free interpretation of the concession granted by Louis XI.[31]

In the wooden frame of the *desco da parto* (literally, 'birth tray') showing a *Triumph of Fame* attributed to Giovanni di Ser Giovanni known as Scheggia and now in the Metro-

Medici coat of arms enclosed in a garland of feathers and diamond rings, from the title page of a manuscript of St Augustine's *Epistolae* illuminated by Monte di Giovanni (BML, Plut. 12.1).

Giovanni di ser Giovanni known as Scheggia, *The Triumph of Fame*, c. 1449 (New York, Metropolitan Museum of Art). On the verso, above the ring and feathers, the arms of the Medici and Tornabuoni families.

politan Museum, New York, we can count (despite the frame's poor state of conservation) four feathers, one after the other: vermilion, green, silver, gold. This tray, used for bringing her meals to a woman who has just been delivered of a child, was the gift of Piero di Cosimo to his wife Lucrezia Tornabuoni on the occasion of the birth of their eldest child Lorenzo in 1449. It may be that in this case the artist exceptionally added a fourth, golden feather to invoke good fortune.[32]

Often used as a decorative motif, the diamond ring with three feathers appears, as we have seen, on the cornice of the tabernacle of the Crucifix in San Miniato al Monte, and on the horse-trappings in Benozzo Gozzoli's fresco of the *Cavalcade of the Magi* in Palazzo Medici. It is by the colours of the three feathers, indeed, that we are able to identify the patrons precisely. In the procession each of the three colours is worn by one of the Kings: we find the *basileus* dressed in green, the Patriarch of Constantinople—or, as Bussagli maintains, the Holy Roman Emperor Sigismund of Luxembourg—in vermilion, and the youngest of the Magi clothed splendidly in white.

In the society of the time colours—like clothes, jewels and the various fabrics—constituted 'taxonomic' elements able to reveal the exact social or political status of the wearer in relation to a group, or of a group in relation to the collectivity. Even the uneducated were capable of 'reading' the meaning of colours: this was every-day knowledge, lacking written documentation at least until the middle of the 15th century.[33]

This chromatic language made use of a grammar of exchanges, combinations and associations; especially in the context of civic ceremony, it served to express agreement or disagreement, love or loathing. The expert medieval eye was able to assess the value of a garment not only by the use of precious materials such as gold or silver thread, pearls and embroideries, but also by the brightness and colour-fastness of the fabrics, and to classify the different textiles in order of nobility. It recognised those in the entourages of noble families by their conspicuous *calze alla divisa*, hose in the traditional family colours; very sophisticated techniques—and unfailingly costly fabrics—were used to produce these parti-coloured garments. The art of dyeing had achieved excellent effects by this time, including a wide range of *sfumati* or shot colours, although the taste of the age tended to prefer, especially on celebratory occasions, clothes in clear, bright colours such as green, red or white.

Colours are symbols, and as such have multiple significations—sometimes contradictory ones. There were in fact no entirely 'positive' or 'negative' colours: it was the combinations and the juxtapositions that established their meaning. Yellow, which in antiquity represented the divine light, retained this positive connotation, and in addition referred to gold; but the combination of yellow and green, for example, suggested treachery, disorder and degeneration—even madness. Since ancient times red had signified strength, courage, love and generosity, but also pride, cruelty and anger, especially—from a certain period—when associated with blue. The economic and commercial interests connected with dyeing substances may have helped to establish some of these associations.[34]

The fact that Lorenzo dresses mainly in white both in the fresco by Benozzo Gozzoli—which, as is generally agreed by scholars, was inspired by a real event, the *armeggeria* or *pas d'armes* of 1459—and at the tournament of 1469 when he was proclaimed the victor, is to be explained by the special value attributed to this colour.

First of all white, like black, was regarded not as a colour but as the sum of all colours. White, in Latin *candidus* (whence *candida-*

tus, a candidate, one who seeks office and is dressed in white) became synonymous with "chastity, honesty, faith, truth, happiness, joy, victory, triumph and sincerity of soul and heart".[35] White garments were worn by popes, by ancient Egyptian priests, by the Vestals.[36]

If we stop to examine the caparison of the horse ridden by the Magus-Lorenzo, and especially the *falsiredini* (the strips of fabric or leather which served to conceal the reins) and the *pettiera* or breast collar, we shall find several Medicean symbols.

The rein-coverings are decorated with a thistle-head motif, while the breast-collar has oval bezants alternating with wheels containing six bezants in a circle, and a seventh in the centre. The thistle-flower (Latin *carduus*), stylised but still recognisable, stands for the victory of good over evil. It is also a symbol of the sin and punishment of Adam and—on account of its prickles—of the Passion of Christ. It appears as an attribute of the Virgin as well: Louis IX founded an order—the famous Order of the Thistle—in honour of the 'Most Holy Mother of God'. According to Isidore of Seville, the goldfinch is called *carduelis* because he feeds on thistles; and as he feeds on the symbol of the Passion, the goldfinch himself is a symbol of salva-

The art of dyeing in a 14th-century miniature from the *Libro delle gabelle* (BR, Ricc. 2526, fol. 12r) and in a 15th-century miniature now in the British Library.

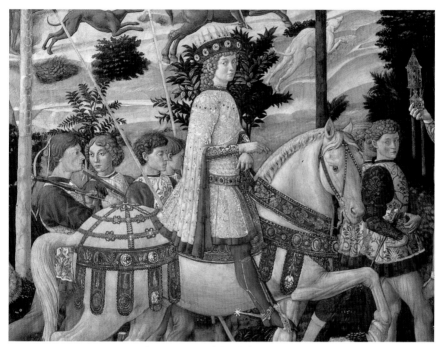

Caspar, the young Magus (Chapel of the Magi, east wall).

tion. Artists such as Botticelli, Carpaccio, Piero della Francesca and Pollaiolo represent the thistle-flower and use it to allude either to the Virgin or to the Passion.[37]

Behind the head of the younger Magus, moreover, we observe a laurel bush, a most eloquent reference to Lorenzo's name: *Laurentius a lauro*. He loved to identify himself with and be recognised by the laurel, symbol *par excellence* of poetry, immortality and glory. In miniatures, for example, the frequent presence of this plant almost certainly indicates Lorenzo's own books, "intended for his personal use".[38] The valuable codex of the collected poems of Dante and Petrarch presented by the Signoria to Charles VIII of France in 1494 has on the verso of the first leaf the famous miniature of the ship-wreck;[39] this image may help us to understand the significance attributed to the laurel. The illuminator was able to translate into visual terms Lorenzo's profound, life-long respect for and love of poetry: the laurel, symbol of poetry, appears as the support which is capable of relieving the sufferings of men, and as the anchor of salvation amid the daily miseries and tempests of human life.

On the livery worn by the man on foot walking in front of Piero's horse, a few paces behind the Magus-Lorenzo, we see the diamond ring embroidered or painted, with a ribbon attached to it bearing the motto *Semper*. The same device is to be seen on the trappings of Piero's horse: in the central part there is a series of interlinked diamond rings with the motto *Semper* inside, while the hanging flaps are embroidered with stylised golden peacock-feathers—Piero the Gouty was especially fond of the peacock, symbol of immortality. On the rein-coverings diamond rings containing seven bezants alternate with a motif of three feathers tied with a narrow ribbon, the form of which recalls the fleur-de-lys, in allusion to the king of France and perhaps also to the city of Florence and her symbol, the lily.

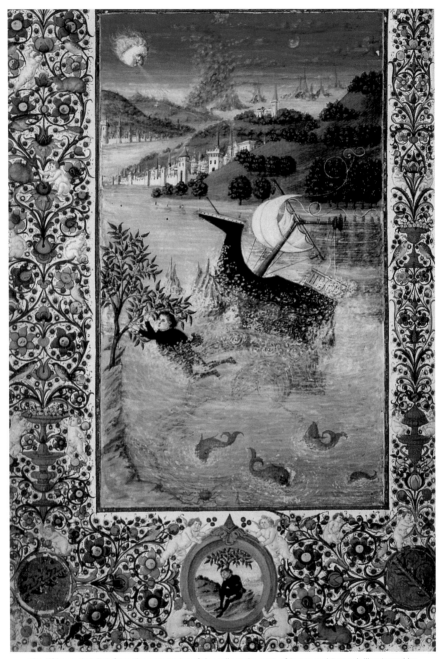

The 'Shipwreck Folio', from the manuscript of the collected poems of Dante and Petrarch illuminated by Francesco di Antonio del Chierico between 1470 and 1480 (BN, Ital. 548, fol. 1v).

The livery of Piero the Gouty's page.

The caparison of Piero the Gouty's horse.

Beside Piero's horse is an old man, also mounted, who is generally identified as Cosimo the Elder. His mule is richly caparisoned, with blue trappings decorated with golden bosses. On the rein-coverings the bosses alternate with what Acidini Luchinat believes to be stylised lanterns. The symbolic significance of these would be comparable to that

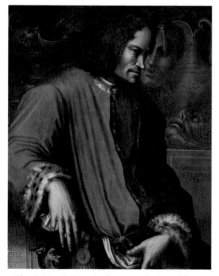

Giorgio Vasari, *Portrait of Lorenzo the Magnificent*, c. 1534 (Florence, Uffizi Gallery).

of the lamp in Vasari's famous portrait of Lorenzo the Magnificent, painted in the 1530s for Duke Alessandro: they proclaim the advent of the enlightened and wise Lorenzo, protected by his father and grandfather.[40]

The diamond rings, interlinked along an imaginary axis so as to form a chain, are fairly frequently encountered either as decorative elements, as for example on the bust of Piero now in the Bargello, or on the clothing of *Minerva restraining the Centaur* by Botticelli (in this case the rings, sometimes three and sometimes four, are linked concentrically), or else as a framing device, as on the pavement of the apartment of Leo X inside Palazzo Vecchio, where we see crowns composed of eight interlinked diamond rings.

Of special interest are the combinations of two or more emblems, which manage to create an original hybrid so striking that the subjects of the emblem impress themselves on the memory. This is perhaps the case with a diamond ring on the architrave of the door to the east of the high altar in the Badia Fiesolana, at the sides of which are two large wings—perhaps falcon's wings; their function may be to attribute greater value to the ring, or else simply to add Piero's personal sign, the falcon, to it, and thus form an original new compound emblem. The wings re-

call the iconology of time and its divisions (evoking the images of Chronos and Mercury of the winged feet) and notions such as promptness, solicitude or fugacity.[41]

The combination of falcon and ring is found again, although with some differences from the Badia version, on the ciborium in the church of San Miniato al Monte, and in the lunette of a lavabo (a basin used for the ritual washing of the priest's hands before Mass) in a small room off the Old Sacristy in San Lorenzo. In both cases a falcon, seen in three-quarter view and with its wings fully spread, grasps in its talons the diamond ring with the motto *Semper*.

During the restoration of what is now regarded as a masterpiece by Donatello,[42] Alessandro Parronchi advanced the theory that the falcon represents an allegory of Time and Prudence in accordance with the *Hieroglyphica* of Horapollo. The vernacular version of this text, printed in 1547, does not however er speak of a falcon, but of an eagle: the latter bird was in fact more common in heraldry, whereas the falcon occurred more often in emblems, where its significance was connected to the courtly tradition which saw in this raptor an erotic metaphor.[43]

In the *Hieroglyphica*, however, the falcon has a different significance. According to Horapollo, for the ancient Egyptians the falcon meant victory, glory, that which is beyond space and time, the divine. The falcon represented "the divinity because it is fecund and long-lived; furthermore, it seems to be the symbol of the sun. It can in fact bear the rays of the sun in its eyes better than any other bird". The falcon also symbolised "height, because it alone can fly vertically upwards; other birds, who are incapable of doing so, have to fly obliquely when they wish to rise"; superiority, "because it is said that this animal drinks not water but blood"; victory, "because it seems able to conquer every other bird: when threatened by a stronger bird, the falcon turns upside down in the air and fights with its talons uppermost, its back and wings below: in this way its adversary, unable to do likewise, succumbs".[44]

The falcon and the ring (tabernacle of the Crucifix, San Miniato al Monte).

The lavabo by Donatello (San Lorenzo).

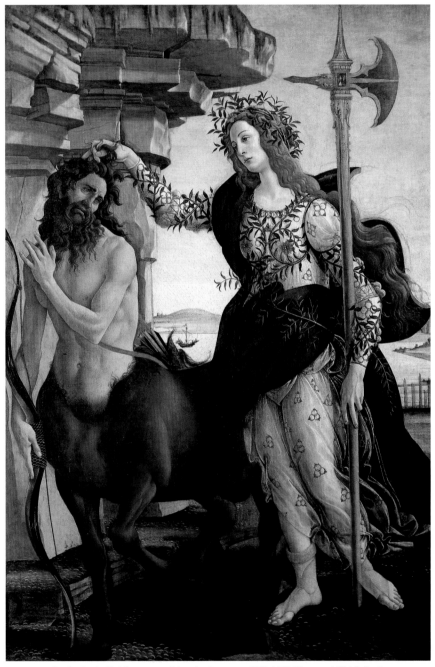

Sandro Botticelli, *Minerva restraining the Centaur*, c. 1480-1488 (Florence, Uffizi Gallery).

The lunette of Donatello's lavabo (San Lorenzo).

While the diamond ring with the motto *Semper*, with or without feathers, refers directly to the Medici family (even though they were not the only ones to make use of this device[45]), there were also much more personal devices: Giovanni di Cosimo, for example, adopted the image of a peacock with the motto *Regarde moi* ('Look at me'), and his brother Piero the Gouty—as we have just seen—a falcon with the diamond ring in its talons and the motto *Semper*. Lorenzo and Giuliano resorted to the entire symbolic patrimony of their family, but had the opportunity, thanks to the wide circulation of allegorical iconography, of combining it with other elements, so as to create highly sophisticated compounds.

While Lorenzo's favourite plant was the laurel, Giuliano's was the olive, a tree whose Latin name (*uliuus*) comes close to being the anagram of his Latin name (*Iulius*, for *Iulianus*). Lorenzo, in particular, adopted emblems that were extremely delicate and evocative both as images and in their content. Recently brought to light as a result of the studies carried out on his illuminated manuscripts now in the Laurentian Library (on the occasion of the five-hundredth anniversary of his death), Lorenzo's emblems are many and may be traced without difficulty in the miniatures of texts either commissioned by

him or dedicated to him. Next to a green parrot, the symbol of eloquence, we find:

Flame with butterflies circling around it. Flame with tree-trunks that feed it. Six Beehives one above the other, with Bees flying around... A rain of Rays coming from the Sun, and of dew falling from Heaven. Ears of golden corn. A lyre with the cipher LZ. Diamond with interwoven laurels, and balls hanging from ribbons tied to the diamond ring.[46]

On the other hand, the symbolic images used by Giuliano reflect the complexities of Neoplatonic thought:

A diamond above, and below a bacchanal with Satyrs playing cymbals and Sistra, and playing various games with the Medici balls. Blades of grass with Ears between the blades, and sometimes without Ears. Tree-stumps with roses, and leaves. Le temps revient. The jasper polished between two wheels.[47]

While miniaturists satisfied the requirements of their patrons by the precision with which they reproduced emblems, civic ceremonies—especially the festivals of courtly origin, where the symbolic language of signs and colours found its maximum expression—presented an extraordinary opportunity to link the family name to a great public event. In the jousts, *pas d'armes* (rare as they

were in Florence) and tournaments, the first phase was always the *mostra*, a parade of symbols, during which the knights and their entourages would flaunt themselves in clothing rich with embroideries and gold before the crowds thronging the piazza. At some of the festivals organised in the second half of the 15th century family history was made, not only because family members took part in these events, but because the family was able to create—or rather to organise—a written memory of them.

At the age of ten Lorenzo appeared in public as a knight in the *pas d'armes* run along Via Larga one April evening in 1459; ten years later he celebrated his twentieth birthday by participating in, and winning, the joust held as usual in the winter months. In February 1475 Giuliano de' Medici was the victor at the joust held in Piazza Santa Croce, thereby demonstrating to all the citizens—friend and foe alike—the power of the family. Eye-witnesses were well aware of the symbolic aspects of such events, and were capable of recording them for posterity. The attention of chroni-

clers focussed not only on the trappings and caparisons of the horses, and on the clothing of the knights and squires, but also on the standards borne before Lorenzo and Giuliano. On them, in fact, the language of symbols managed to expound upon what the emblems could only hint at.

When Lorenzo appeared as *messere della brigata* ('lord and master of the brigade') in the *pas d'armes* of 1459, he was awarded not only the staff which was the symbol of his office, but also a standard embroidered or painted with a "flying falcon of gold / being taken in a net".[48] According to the customary courtly interpretation, the falcon and the net alluded to hunting, the pastime of youth, and to its erotic equivalent: amorous venery. Read in Horapollonian terms, however, Lorenzo's device—possibly a variant of his father's—alluded also to victory and glory. As we have seen, the *insegna* was not always a wholly private and personal symbol, but was in a certain sense part of the family possessions, and was carefully studied in its tiniest details by the entire group. The standard of

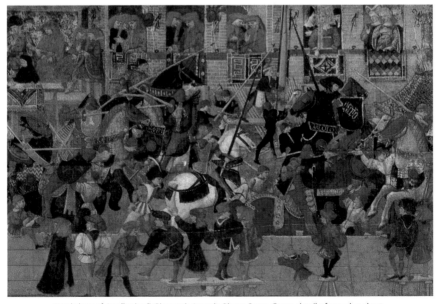

Workshop of Apollonio di Giovanni, *Joust in Piazza Santa Croce*, detail of wooden chest,
c. 1439 (New Haven, Yale University Art Gallery).

Group of knights in armour, from the title page
of the 15th-century edition of Luigi Pulci's
Joust of Lorenzo de' Medici.

Horse and knight in armour, from the title page
of the first edition of Politian's *Stanze for
the Joust of Giuliano de' Medici.*

1459—probably Lorenzo's first 'public statement'—can be interpreted as a reference to the social and political position of the Medici. His very position as *messere* might allude to his family's political pre-eminence: Lorenzo was lord of Florence at least in the make-believe of an evening, with the hope that the play-acting might one day become reality.

Lorenzo's and Giuliano's standards express with symbolic richness the maturity achieved by the two youths and their programme for life. Documented in a poem by Luigi Pulci and in an anonymous text, Lorenzo's standard, which according to some was the work of Andrea del Verrocchio, was carried by a page who headed the procession of the *mostra* "dressed in a short gown of white and violet [*pagonazzo*] velvet, with a cap of the same stuff". The same colours appeared on the standard:

of white and violet taffeta with the sun at the top, and a rainbow beneath; and in the midst of the said standard there was a lady standing in a meadow dressed in Alexandrine cloth embroidered with gold and silver flowers; and spreading on the violet field a laurel stump with several dead branches, and in the middle a green branch spreading onto the white field, and the said lady gathers from the said laurel and makes a garland of it, sowing all the white field with it, while the violet field is sown with branches of dead laurel.[49]

Much has been written about the sun as the *senhal* ('fictitious name') for Lucrezia Donati

and about the erotic message of the standard. What has perhaps been overlooked is the relationship between the sun, the rainbow and the motto, which not by chance is in French, the language of courtly love. In this context the motto would seem to refer to the return of spring, the season of amorous dalliance. But in fact the motto *le tems revient* seems a faithful translation of a famous verse in Virgil's fourth Eclogue, *magnus ab integro saeclorum nascitur ordo*: it is the announcement of the return of Astraea, of the renewal of time. Such an announcement has since Virgil's time been interpreted in political and imperial terms: the presence of the sun, one of the symbols of empire, confirms this reading, while the rainbow—symbol of peace, justice and the covenant between man and God (the reconciliation sign manifested by God after the Flood in Genesis 9:13–17)—bears witness to the biblical promise: with the rainbow, a bridge between heaven and earth, peace and justice and order return once more.

However, if the joust of 1469 can still be seen as an expression of courtly culture, the one of 1475 marks the beginning of a new age, as Politian's poem makes abundantly clear. In his verses—left unfinished because of the untimely death of Simonetta Cattaneo, shortly followed by the death of Giuliano—we note the change that has taken place: intent on catching the Neoplatonic philosophical resonances, the poet interprets Giuliano's participation as a rite of initiation. According to an

Simonetta Cattaneo Vespucci and Giuliano, from the first edition of Politian's *Stanze for the Joust of Giuliano de' Medici.*

anonymous source, on a horse "covered with Alexandrian taffeta, scalloped and fringed" rode a standard-bearer holding in his hand "a great staff painted azure on which was a standard of Alexandrian taffeta scalloped and fringed in the round". In the upper part a sun was painted, and in the centre of the standard

a large figure resembling Pallas, wearing a dress of fine gold reaching half way down her legs, and beneath a white tunic embroidered with gold, and a pair of azure boots, who stood on two flames of fire and from the said flames there emerged flames which burned olive branches which were in the lower half of the standard, while in the upper half were branches without fire. She had on her head a burnished helmet in the ancient fashion, and her hair was all in plaits that waved in the wind. The said Pallas held in her right hand a jousting lance, and in her left the shield of Medusa. And near the said figure a meadow full of flowers of various colours, out of which rose an olive trunk with a large branch, to which was tied a god of love with his hands tied behind him with golden cords. And at his feet his bow, quiver and arrows were broken. On the olive branch where the god of love was tied was a motto in golden letters written in French which said *La sans par* ['The Unequalled']. The above-mentioned Pallas gazed fixedly at the sun which was above her.[50]

The symbolic language of the standard had its intended effect and intrigued the onlookers, who no doubt found it hard to interpret the significance of these images.

Many of them took the subject to be the victory of Chastity over Cupid: Pallas Athena conquers the god of love who, tied to the olive trunk, is compelled to abandon his broken bow and arrows. "Some say one thing and some another, but nobody is of the same opinion; and this is the beauty of painted images", wrote Aurelio Augurelli.[51]

The device of the burning *bronconi* ('cut branches') on the standard has exercised the wits of both 16th-century and modern emblem-interpreters. Possibly less than adequate attention has been paid to the fact that the fire-brand or ember has been connected with Eros since antiquity, and has a different meaning according to whether it is green or dead, burning or not. On that occasion *Iulius* chose for himself and for his entourage the image of the burning olive-branch to show that, despite his 'green' age, his heart burned with love and that the power of love was capable of performing nigh-impossible deeds.[52]

Piero di Cosimo, *Cleopatra*, possibly a portrait of Simonetta Cattaneo Vespucci, c. 1480 (Chantilly, Musée Condé).

Coat of arms, ring and *broncone*, from a manuscript of Cristoforo Landino's *Disputationes Camaldulenses* (BML, Plut. 53.28, fol. 1*r*).

This device with its amorous connotations was shared by Giuliano's brother Lorenzo, who as well as the branch of flaming laurel (a variant of the whole tree) used the *broncone* with rose-shoots, probably alluding—at least according to some scholars—to his marriage with Clarice Orsini.[53]

We find cut branches of laurel with and without mottoes; the clothing worn for the 1469 joust, for example, was according to the chronicle embroidered with "a green transverse branch":[54] and a cut branch of the same colour, with a flying scroll bearing the motto *Semper virens* ('Evergreen'), appears on a hexagonal brick now displayed in the Museum of the Bargello, Florence. The emblem of burning brands of laurel—according to Jovius—continued to be used even in later times by Lorenzo's elder son Piero (known as the Unfortunate), and then by Piero's own son Lorenzo Duke of Urbino (who was born in 1492, the year of the Magnificent's death).

Each *broncone* is a severed branch, separated from the trunk and from the earth, and therefore destined to die. But, despite the lack of vital lymph, the *broncone* obstinately continues to regenerate itself, to sprout—like the laurel-branch, evergreen, immortal, indestructible; and to burn without ever being consumed—like the olive-branch, which carries within itself the oily substance capable of feeding a flame perpetually, the symbol of passion and ardour, and of the divine light.

To discover the symbolic origins of the *broncone* in all its variants we have to look at different traditions and to recognise the possibility of influence from other cultures. The image of the branch that is cut but still capable of flowering has links with the classical world, with its myths of death and rebirth, as well as with the Jewish Kabbala and with the Christian tradition which associates the severed but flowering branch with the Resur-

The evergreen *broncone* (Bargello Museum).

Giuliano kneeling in prayer in front of Venus and burning branches, from the first edition of Politian's *Stanze for the Joust of Giuliano de' Medici*.

rection of Christ and the victory of life over death. We can easily imagine how the spiritual and philosophical traditions of the East, already present in the culture and everyday life of Florence, might have influenced the visual and symbolic development of the image of the *broncone*.[55]

However, we should not forget—alongside these cultural stratifications—the possible Burgundian origin of this symbol. Exchanges between Florence and the Dukedom of Burgundy were multiple, and in Via Larga the attraction of the 'Great Dukes of the West' was fully felt, despite the fact that they were the traditional rivals and enemies of the French crown, Florence's ally. The 'staffs of Burgundy' forming a St Andrew's Cross, and the flames, were part of the insignia of the Order of the Golden Fleece, founded by Duke Philip the Good, and they may have in part—if only on a formal level—inspired the Medicean *bronconi*.

The *broncone* and the Medicean balls together with the *Agnus Dei* of the Wool Guild, the angel of the Cathedral Chapter, the lion of the Republic (or Marzocco), the Cross of the People and the Florentine lily, from an antiphonary illuminated by Monte di Giovanni between 1513 and 1526 (AOSMF, Cod. C n. 11, fol. 4*v*).

NOTES

1 Bartolo da Sassoferrato, *Tractatus de insigniis et armis*, in *Consilia et Quaestiones* (Venetia: apud Juntas, 1590), xi, fols. 124*v*–126*r*.

2 Quoted in V. Viti, *La Badia Fiesolana. Pagine di storia e d'arte* (Florence: Vallecchi, 1956), 28–29.

3 R. Bizzocchi, *Chiesa e potere nella Toscana del Quattrocento* (Bologna: Il Mulino, 1987), 93.

4 Ser Giusto di Giovanni Giusti d'Anghiari, *Memorie dal 1437 al 1482* (BNCF, Ms. ii.ii.127), fol. 122*v*.

5 G. Imbert, "Origini leggendarie e origini storiche della famiglia dei Medici", *Nuova Rivista Storica*, 27 (1943), 39–48.

6 According to S. Tolkowski ("Le palle dei Medici. Un indovinello fiorentino", *Marzocco*, 8 March 1931, 4) the Medicean insignia were nothing but "ordinary oranges, of the more bitter species, the only one cultivated in Italy around 1300, whose peel is indeed of a pronounced red colour. It was in commerce with the Levant that the principal Tuscan merchant families made their fortunes".

7 The expression *semé of bezants* means that the bezants are strewn or scattered on the field.

8 L. Borgia and F. Fumi Cambi Gado, "Insegne araldiche e imprese nella Firenze del Quattrocento", in M.A. Morelli Timpanaro, R. Manno Tolu and P. Viti (eds.), *Consorterie politiche e mutamenti istituzionali in età laurenziana*, exhibition catalogue: Florence, Archivio di Stato, May 4–July 30, 1992 (Cinisello Balsamo: Silvana, 1992), 217.

9 F. Cardini, "Le insegne Laurenziane", in P. Ventrone (ed.), *Le Tems Revient, 'l Tempo si rinuova. Feste e spettacoli nella Firenze di Lorenzo il Magnifico*, exhibition catalogue: Florence, Palazzo Medici Riccardi, April 8–June 30, 1992 (Cinisello Balsamo: Silvana, 1992), 59.

10 Possibly a palm branch; see F. Fumi Cambi Gado, "Emblemi a Firenze in epoca laurenziana", *Archivio Storico Italiano*, 150/3 (1992), 725.

11 BML, Plut. 82.17, fol. 3*r*.

The arms of the Moneychangers' Guild, a *semé of bezants*, on the façade of the Tribunale di Mercatanzia in Piazza Signoria.

Hugo van der Goes, *Trinity Altarpiece* (Edinburgh, National Gallery of Scotland): the lion of the kings of Scotland is depicted in the position *rampant*.

12 R. Brogan, *A Signature of Power and Patronage: the Medici Coat of Arms, 1299–1492* (New York: P. Lang, 1993).

13 'Passant', said of an animal, means walking, three paws on the ground, the right fore-paw raised.

14 See W. Roscoe, *The Life of Lorenzo de' Medici, called the Magnificent*, 2 vols. (Liverpool: J. M'Creers, 1795), where the author transcribes an autograph document (two folios of memoirs) from two codices in the Libreria Magliabechiana, Florence.

15 A miniature by Matteo Bosso in the *De veris ac salutaribus animi gaudiis dialogus*, which bears a dedication by Politian to Lorenzo the Magnificent, shows an unusual Medici coat of arms: the six roundles are all gules, including the upper one with the fleurs-de-lys. This incunabulum is now housed in Amsterdam (Bibliotheca Philosophica Hermetica, 63).

16 Borgia and Fumi Cambi Gado, "Insegne araldiche", 219.

17 ASF, Diplomatico, Medici, May 1465.

18 M. Pastoureau, *Traité d'héraldique* (Paris: Picard, 1979), 160–164. By the same author, see also *Heraldry. An introduction to a noble tradition* (New York: H.N. Abrams, 1997).

19 BML, Plut. 53.2, fol. 5.

20 From the 1530s onwards important works were published on this subject in Italy: Andrea Alciati's Latin treatise *Emblemata* (1534) was followed by Paulus Jovius' *Dialogo dell'imprese mili-*

tari e amorose (1555) and *Ragionamento sopra i motti, e disegni d'arme, e d'amore, che communemente chiamano imprese*—published in 1556 together with Girolamo Ruscelli's *Discorso intorno all'inventioni dell'imprese, dell'insegne, de' motti, e delle livree*—and by Torquato Tasso's dialogue *Il conte, overo de le imprese* (1594).

21 See R. Paultre, *Les images du livre. Emblèmes et devises* (Paris: Hermann, 1991), 44–45.

22 A. Rado, *Dalla Repubblica fiorentina alla Signoria medicea. Maso degli Albizzi e il partito oligarchico in Firenze dal 1382 al 1393* (Florence: Vallecchi, 1926), 51–52.

23 BML, Plut. 40.3, fol. 1.

24 BML, Plut. 76.37, fol. 1.

25 BML, Plut. 54.23, fol. 1.

26 These are three roundels now in the museum of Castel Sant'Angelo, Rome, two of them encircled by the diamond ring. The first has a lion's head—in evident allusion to the name assumed by the pope—gnashing its teeth; the second has three plumes (red, green and white) tied by a flowing scroll with the motto *Semper*. The third roundel is encircled by an unusual garland of tree-stumps, and bears a yoke with the motto *Suave*: see F. Quinterio, "Natura e architettura nella bottega robbiana", in G. Gentilini (ed.), *I Della Robbia e l'«arte nuova» della scultura invetriata*, exhibition catalogue: Fiesole, basilica di Sant'Alessandro, May 29–November 1, 1998 (Florence: Giunti, 1998), 57–85 and, in the same volume, the entries referring to Medici coats of arms (314–316).

Medici coat of arms, from an incunabulum of Matteo Bosso's *De veris ac salutaribus animi gaudiis* (Amsterdam, BPH, 63): the roundle with the fleurs-de-lys of France is not azure, but gules like the other ones.

Medicean device with feathers and diamond rings
(Florence, Bargello Museum).

Medicean device with feathers and the motto *Semper*,
from a manuscript of Brandolini's *De comparatione
reipublicae et regni*, c. 1491 (BR, Ricc. 672, fol. 1r).

27 White, red and green (*argent, gules, vert*) were also the tinctures of the Parte Guelfa: the Medici may have deliberately chosen to share them, surely recalling the advantages they had gained during the 14th century, when the Parte Guelfa had control of the city government (see Fumi Cambi Gado, "Emblemi a Firenze", 728).

28 P. Giovio, *Dialogo dell'imprese militari e amorose*, edited by M.L. Doglio (Rome: Bulzoni, 1978), 63. In Dante, red, white and green are the colours worn by Beatrice when she appears to him (*Vita Nova*, ii[i], 3; iii[ii], 1 and 4; xxiii, 8; *Purgatorio*, xxx, 31–33).

29 C. Acidini Luchinat, "L'immagine medicea: i ritratti, i patroni, l'araldica e le divise", in F. Borsi (ed.), *«Per bellezza, per studio, per piacere». Lorenzo il Magnifico e gli spazi dell'arte* (Florence: Giunti–Cassa di Risparmio, 1991), 139.

30 A. Segni, *Raccolta delle imprese, Cimieri, Rovesci di medaglie e altri Simboli, usati in diverse occasioni dai personaggi della Ser.ma Casa di Toscana* (BML, Ms. Ashburnham 688), fol. 5r.

31 Fumi Cambi Gado, "Emblemi a Firenze", 730.

32 This was suggested by Cristina Acidini in "Lorenzo il Magnifico: divise e messaggio morale", in *La Toscana al tempo di Lorenzo il Magnifico. Politica, Economia, Cultura, Arte*, Convegno di Studi promosso dalle Università di Firenze, Pisa e Siena: November 5–8, 1992 (Pisa: Pacini, 1996), 39–40. On the back of the tray are the coats of arms of Piero de' Medici and Lucrezia Tornabuoni, who

married in 1448, and in the centre the diamond ring encircling three feathers, with a scroll bearing the motto *Semper*. In this case the motto may also be taken as a declaration of eternal love.

33 Between 1435 and 1458 appeared a work by Sicile, herald to Alphonse V king of Aragon, entitled *Le blason des couleurs en armes, livrées et devises*, which expounds in clear and concrete fashion the colour symbolism of the daily life of the time.

34 See M. Pastoureau, *Couleurs, images, symboles. Études d'histoire et d'anthropologie* (Paris: Le Léopard d'or, 1989); id., *Figures et couleurs. Études sur la symbolique et la sensibilité médiévales* (Paris: Le Léopard d'or, 1986).

35 Giovanni de' Rinaldi, *Il mostruosissimo mostro, diviso in due trattati, nel primo de' quali si ragiona del significato de' colori, nel secondo si tratta dell'herbe, e fiori* (Venetia: appresso Lucio Spineda, 1599), 18. The first edition of this work was published in Ferrara in 1584.

36 G. Romey, *Dictionnaire de la symbolique* (Paris: Michel, 1995), 59–60.

37 See M. Levi d'Ancona, *The Garden of the Renaissance. Botanical symbolism in Italian painting* (Florence: Olschki, 1977), *ad vocem*.

38 A. Dillon Bussi, "Aspetti della miniatura ai tempi di Lorenzo il Magnifico", in A. Lenzuni (ed.), *All'ombra del lauro. Documenti librari della cultura in età laurenziana*, exhibition catalogue: Florence, Biblioteca Medicea Laurenziana, May 4–June 30, 1992 (Cinisello Balsamo: Silvana, 1992), 151.

39 BN, Ital. 548, fol. 1*v*. The manuscript was illuminated by Francesco d'Antonio del Chierico for Lorenzo around the 1470s.

40 C. Acidini Luchinat, "La Cappella medicea attraverso cinque secoli", in G. Cherubini and G. Fanelli (eds.), *Il Palazzo Medici Riccardi di Firenze* (Florence: Giunti, 1990), 86–87. The theme of the lantern appears frequently in the Old and the New Testament; it is the symbol of the divine light which must not be hidden beneath a bushel but raised up for all to see; its guiding force penetrates the darkness of the night and the shadows of the world (Psalms 119:105, 18:29; Proverbs 6:23; Job 29:23; Matthew 5:14–16, 25:1–13; Luke 8:16, 11:33–36, 12:35; John 8:12).

41 See G. Cairo, *Dizionario ragionato dei simboli* (Bologna: Forni, 1967; photographic reprint of the original edition Milan, 1922), *ad vocem*; J. Hall, *Dictionary of subjects and symbols in art* (London: J. Murray, 1974; revised edition 1979), *ad vocem*.

42 According to Alessandro Parronchi ("L'arpia svela: è Donatello. Nuovi studi, e una nuova attribuzione per il lavabo della Sacrestia Vecchia", *La Nazione*, 4 January 1991, 4), the authorship of the lavabo is revealed especially in the heads of the animals, particularly the harpies. Parronchi's thesis was a revolutionary one, given the almost unanimous view of earlier critics that the lavabo was the work of Andrea del Verrocchio, and was to be dated around the 1470s: it was thought to show "a derivation from the Marsuppini tomb by Desiderio da Settignano in Santa Croce"; see A. Busi-

gnani (ed.), *Verrocchio* (Florence: Sadea/Sansoni, 1966), 36.

43 See F. Cardini, "Il banchetto del falcone, ovvero l'amante mangiato", *Quaderni Medievali*, 13 (1981), 45–71.

44 These translations are based on the text of Horapollo, *I geroglifici*, introduction, Italian translation and notes by M.A. Rigoni and A. Zanco (Milan: Rizzoli, 1996), 87–88. For an English translation, see *The Hieroglyphics of Horapollo*, translated by G. Boas, with a new foreword by A. Grafton (Princeton, N.J.: Princeton University Press, 1993; 1st edition New York: Pantheon Books, 1950).

45 The diamond ring was used by other Florentine families, such as the Rucellai and the Salimbeni: the former marked their palazzo in Via della Vigna and the church of Santa Maria Novella with rings and feathers, "probably deriving the motif of the ring, as did the Medici themselves, from contacts with the Sforza and Este courts" (Acidini Luchinat, "L'immagine medicea", 139). On the diamond ring of the Salimbeni, on the other hand, blossomed three poppies with the motto *Per non dormire* ('So as not to sleep'), as we see on the shutters in Via Porta Rossa and on the façade of their palazzo in Piazza Santa Trinita.

46 Anonymous text quoted in Acidini Luchinat, "L'immagine medicea", 141.

47 Ibid.

48 Anonymous verses quoted in G. Volpi, *Le feste di Firenze del 1459. Notizie di un poemetto del secolo XV* (Pistoia: Pagnini, 1902), 22.

Marble inlays designed by Leon Battista Alberti depicting feathers and diamond rings, the arms of the Rucellai family (Rucellai Chapel, tempietto of the Holy Sepulchre).

Luca della Robbia the Younger, glazed polychrome terracotta with Medicean emblems c. 1518 (Rome, San Silvestro al Quirinale, Chapel of Santa Caterina).

49 The passage quoted is an anonymous transcription of the Codice Magliabechiano VIII.1503; see P. Fanfani (ed.), "Ricordo d'una giostra fatta a Firenze a dì 7 febbraio 1468 sulla piazza di Santa Croce", *Il Borghini*, 2 (1864), 538. On Lorenzo's standard, see Luigi Pulci's *La Giostra*, in *Opere Minori*, edited by P. Orvieto (Milan: Mursia, 1986), lxiv–lxv, 86): "…e presso a uno alloro / colei che per exempro il ciel ci manda / delle bellezze dello etterno coro / ch'avea tessuta mezza una grillanda, / vestita tutta âzurro e be' fior d'oro; / e era questo alloro parte verde, / e parte, secco, già suo valor perde" ('…and by a laurel / she whom the heavens send us as an example / of the beauties of the eternal choir / had woven a half-garland, / [she who was] all dressed in azure and fair flowers of gold; / and this laurel was part green, / and part had withered, and lost its merit').

50 BNCF, Ms. Magl. II.IV.324, fol. 122*v*.

51 Quoted in R.M. Ruggieri, "Letterati, poeti e pittori intorno alla giostra di Giuliano de' Medici", *Rinascimento*, 10 (1959), 172–173.

52 The famous woodcut illustrating the final strophes of Politian's *Stanze* has been the subject of numerous studies, and the burning brands forming a St Andrew's Cross have been interpreted in many different ways. On this subject, see S. Settis, "Citarea «su un'impresa di bronconi»", *Journal of the Warburg and Courtauld Institutes*, 34 (1971), 135–177.

53 See Borgia and Fumi Cambi Gado, "Insegne araldiche", 231; Dillon Bussi, "Aspetti della miniatura", 250.

54 Fanfani (ed.), "Ricordo d'una giostra".

55 The flaming olive-branch is mentioned in the Koran (xxiv, 35).

TABLE OF CONTENTS

Printed by Alpilito – Firenze
November 2001